HOW TO DRAW

Still Life

A STEP-BY-STEP GUIDE FOR BEGINNERS WITH 10 PROJECTS

IAN SIDAWAY

NEW HOLLAND

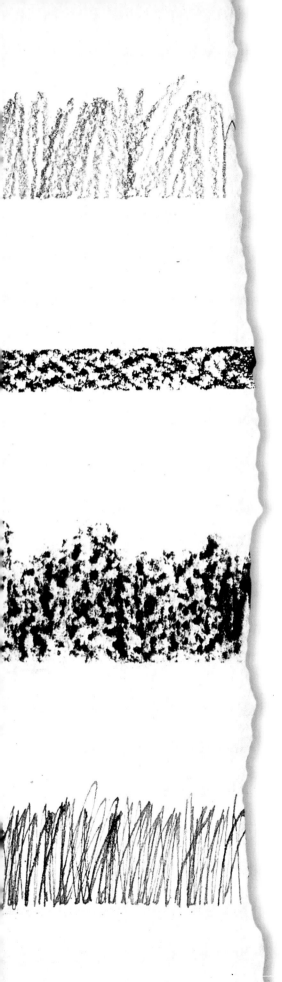

First published in 2003 by
NEW HOLLAND PUBLISHERS (UK) LTD
London • Cape Town • Sydney • Auckland

Garfield House
86–88 Edgware Road
London W2 2EA
www.newhollandpublishers.com

80 McKenzie Street
Cape Town 8001
South Africa

Level 1, Unit 4
14 Aquatic Drive
Frenchs Forest, NSW 2086
Australia

218 Lake Road
Northcote
Auckland
New Zealand

10 9 8 7 6 5 4 3 2 1

ISBN 1 84330 382 5

Senior Editor: CLARE HUBBARD
Design: BRIDGEWATER BOOK COMPANY
Photography: IAN SIDAWAY, SHONA WOOD
Editorial Direction: ROSEMARY WILKINSON
Production: HAZEL KIRKMAN

Reproduction by Pica Colour Separation, Singapore
Printed and bound by Times Offset (M) Sdn. Bhd., Malaysia

NOTE
Every effort has been made to present clear and accurate
instructions. Therefore, the author and publishers can offer no
guarantee or accept any liability for any injury, illness or damage
which may inadvertently be caused to the user while following
these instructions.

Contents

Introduction

Give anyone a pencil and a piece of paper and they will begin to draw. It's as if a forgotten mental mechanism clicks in and the process begins without any coaxing. Admittedly the results may be crude, but the desire to make marks on a surface is almost compulsive. As children we draw before we can write. The act is instinctive, all children do it. What a shame that as the act of writing takes precedence, drawing, due to lack of practice, becomes a forgotten skill.

Drawing is of immense importance to the visual artist, it underpins everything the artist does. The artist's vocabulary consists of abstract marks and techniques which are combined visually to make a coherent image. Learning how to do this requires two distinct disciplines. The first is learning how to really "look" at things and the second is learning how to thoroughly exploit the tools and materials being used.

We look at things all the time. But do we really see them? The artist is trained to consider and take specific note of those things which an untrained eye might not consider important. These include not only shape and size, but also the quality of the light, shade and tone, colour and texture, perspective and composition.

The second discipline involves learning the techniques and the full potential of the materials. A successful drawing combines technical skill and vision. Technical skill is the easier of the two to learn. It comes with practice and experimentation. The more confidence you have in handling your

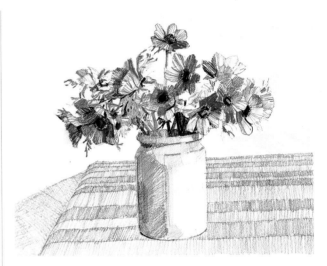

ABOVE All of the elements in a still life can be manipulated by the artist, including the subject matter, lighting, colour and composition.

materials, the more accomplished your drawings will become. The aim is to become so familiar with your materials that you develop an instinctive feel when handling them. This frees the mind for concentrating on "looking" and helps give the drawing that look of accomplished spontaneity.

Still life comes from the Dutch *stil leven,* meaning the "representation of a motionless aspect of nature". It presents the perfect subject matter for learning how to draw. All of the elements that are present in a still life arrangement can be manipulated by the artist. An added advantage is that the subject will not move or change. Flowers, fruit and vegetables will wither and die over time but not for several days or even weeks, giving plenty of time for the drawing to be completed with little or no pressure.

Using the Book

The 10 demonstrations cover a wide range of materials, techniques and subjects. They become more complex and involved as you progress through the book. The lessons learnt whilst doing them are cumulative and what is learnt on one can be carried forward to the next, so the absolute beginner may find it better to begin with Demonstration 1 (see pages 18–23), however the more adventurous can dip in wherever they please. In addition to the main drawing, each demonstration also includes an alternative drawing of the same or a similar subject, made using a different drawing material and

is there to show further possibilities. A photograph of an alternative set-up is also included for you to attempt your own treatment and variation without having to set up your own arrangements.

The treatments for each demonstration are only suggestions. After you have progressed through the book try using a dip pen and ink for demonstration 1 instead of pencil or try a descriptive charcoal drawing of Demonstration 7 (see pages 54–59).

The variations and possibilities are endless and this book is only the starting point. The most important thing is to enjoy drawing.

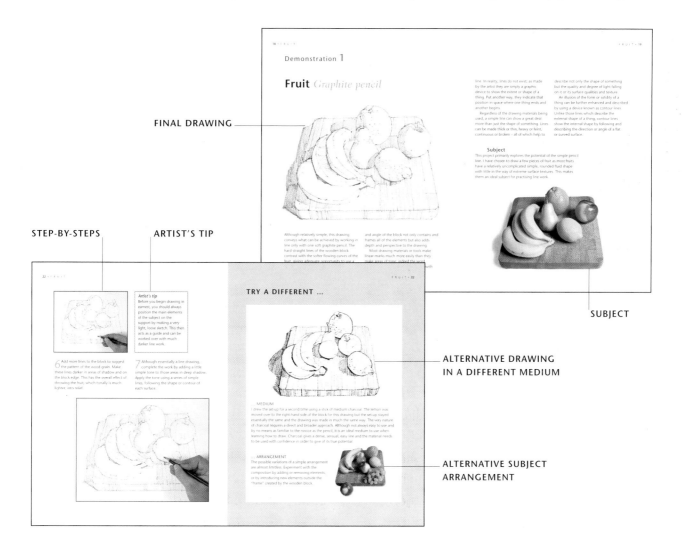

FINAL DRAWING

STEP-BY-STEPS

ARTIST'S TIP

TRY A DIFFERENT ...

SUBJECT

ALTERNATIVE DRAWING IN A DIFFERENT MEDIUM

ALTERNATIVE SUBJECT ARRANGEMENT

Tools and Materials

This section describes and explains the materials used in each of the demonstrations. Use it as a guide when you are purchasing your equipment. Fortunately, most drawing materials are relatively inexpensive and capable of producing many drawings before they need to be replaced.

PENCILS The one drawing tool familiar to everyone is the "lead" pencil. It is not, and never was, made of lead but of graphite.

Graphite pencils run from 9H – the hardest, which makes a very pale grey line – down to H and HB. (F stands for fine.) The grades then run from B up to 9B – the softest, this makes the darkest line of all. You should always remember that each grade of pencil will give an optimum dark tone and applying more pressure will not make that tone any darker. If you require a darker tone then you will need to use a softer grade pencil. It is for this reason that drawings are usually made with a pencil which is at least HB or softer.

PENCILS

GRAPHITE STICKS Today, many artists use graphite sticks for drawing. These are simply thicker versions of the same graphite strip found in pencils. Available in HB, 3B, 6B and 9B grades, they have several advantages over the orthodox "wooden" pencil. The barrel shape is round, with some brands being coated in a thin plastic paint. This keeps the fingers clean and is removed as the pencil is sharpened. The shape of the stick means that as the stick is sharpened a large area of graphite is always exposed. This makes it possible to create not only fine lines, which by altering the angle at which the stick comes into contact with the support can be made into very thick lines, but also broad areas of flat tone. Thicker, dumpy sticks are also available. These are hexagonal in shape and available in a similar range of soft grades. Both types of graphite stick are sharpened using a pencil sharpener or by rubbing on fine sandpaper. The resulting powder can be rubbed onto drawings to create tone. If a larger quantity is needed it can be purchased from art stores.

CHARCOAL Made from carbonized wood (usually willow, but beech or vine can also be found), the sticks are graded as soft, medium or hard and thin, medium or thick. Extra large, thick sticks are also available; these are known as "scene painters' charcoal".

Compressed charcoal is much harder and cleaner to use than stick charcoal. It is graded into hardness and density and can be found with both round and square profiles. Compressed charcoal is also made into charcoal pencils with either wooden or wrapped paper barrels.

Both stick and compressed charcoal is best sharpened using a sharp utility knife or by

rubbing the stick on fine sandpaper. The marks made when using stick charcoal and, to a lesser extent, compressed charcoal, are dusty and sit on the support surface, so will need fixing to prevent them from being smudged.

ARTISTS' PENCILS, CARRE and CONTE STICKS
A range of artists' pencils and carré sticks are available including the traditional pigment colours of white, sepia, sanguine, bistre and black. The pencils resemble traditional pencils and are sharpened in the same way. The carré sticks are solid pigment and square in profile; these are best sharpened with a utility knife. Many of the pencils have a wax content and unlike soft graphite, charcoal or carré sticks, can be used without fixing. Conté chalks are natural pigments bound with gum Arabic. The most popular colours are black, white, browns, rusts and reds. They are effective for crisp lines and areas of solid tone.

COLOURED PENCILS and PASTEL PENCILS
Coloured pencils are made in a similar way to graphite pencils. The pigment is mixed with clay filler and a binder and this mixture is then impregnated with wax. This acts as a lubricant, helping the pencil slide smoothly over the support and fixing the colour to it. Pastel pencils, although similar to coloured pencils, are made from a strip of hard pastel secured in a wooden barrel. The mark is not as permanent as that made with coloured pencils and needs to be fixed. They are, however, very easy to work with and make very strong drawings. They are especially effective when used on a coloured support. As with traditional pencils, both are best sharpened using a sharp utility knife.

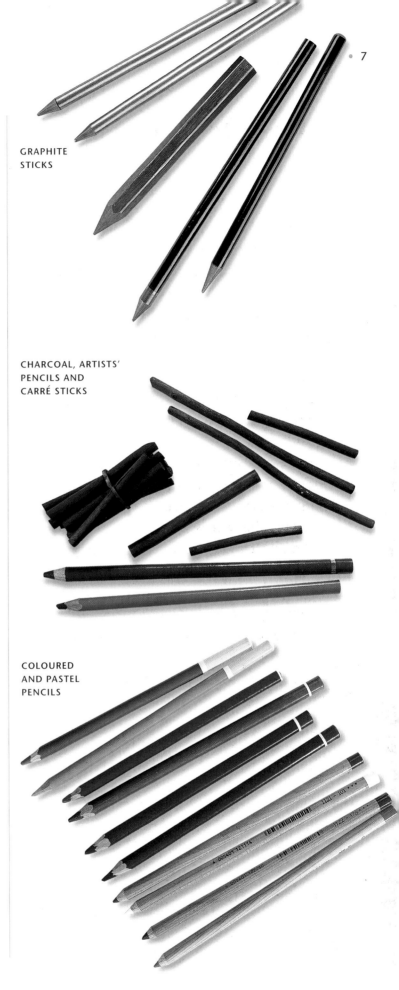

GRAPHITE STICKS

CHARCOAL, ARTISTS' PENCILS AND CARRÉ STICKS

COLOURED AND PASTEL PENCILS

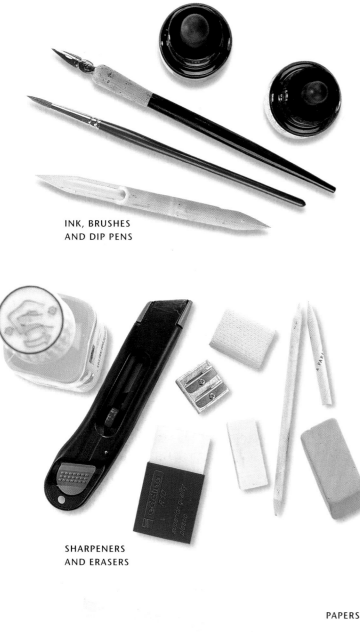

INK, BRUSHES
AND DIP PENS

SHARPENERS
AND ERASERS

PAPERS

SHARPENERS Pencil sharpeners create a neat point and are needed for graphite sticks. For all other pencils and sticks a better result is achieved using a sharp craft or utility knife. These enable the point to be sharpened to suit the style of work in hand; it can be made long or short, or even sharpened at an angle.

ERASERS and STUMPS The putty rubber is soft and malleable; it can be used for cleaning large areas and lightening tone or pulled into a point to put in highlights. Putty rubbers get dirty when used with charcoal, soft graphite or carré sticks. The answer is to cut the rubber into pieces, which, once dirty, can be thrown away. Harder, plastic erasers can be used on edge to make crisp, incisive lines in areas of tone. Alternatively, use the sharp corners to make pattern or describe texture. Care should always be taken when using erasers not to disturb the surface of the paper support.

A useful drawing aid is the stump or torchon, sometimes called the tortillion. It is used to manipulate and blend the loose pigment on the drawing, pushing it into the support surface. The stump point becomes dirty with use but can be cleaned by rubbing it on fine sandpaper.

FIXATIVE To prevent drawings made with pencil, charcoal or other soft pigment materials from being smudged they need to be fixed. Be sure to follow the manufacturer's instructions when using it. Bear in mind that, once fixed, the drawing cannot be altered by using an eraser. You can, however, work on top of a fixed drawing and it is common practice to fix a drawing periodically whilst it is being made.

INK Ink is either waterproof or non-waterproof. One can be used with the other if each is allowed to dry before applying the other, but it is best not to mix the two when wet. Waterproof inks can be diluted with water. Non-waterproof inks can also be diluted with water but, unlike waterproof inks, are soluble when dry. This makes it possible to re-wet dry areas and make corrections by blotting with a paper towel.

Perhaps the best known drawing ink is black Indian ink, which was originally from China. When diluted with water this ink becomes a pleasant deep sepia colour.

BRUSHES and DIP PENS The traditional tool for applying ink is a brush. Sable brushes are best of all; they hold large quantities of liquid and, if looked after, keep their point.

Dip pens are available in a variety of shapes. They take interchangeable steel nibs which are also available in a range of sizes with pointed, square or rounded ends. Certain nibs only fit certain pens, so try before you buy. Occasionally you may find that a new nib is reluctant to accept the ink. This can be solved by rubbing a little saliva onto the nib.

Two alternatives to the steel nib dip pen are the bamboo and the reed pen. Bamboo pens make a coarse, textural line better suited to bolder drawings. The reed pen delivers a much finer, flexible line.

ART, BALLPOINT and TECHNICAL PENS Fountain pens, art pens, rollerballs, ballpoints, fibre-tips, nylon-tips, technical pens and fine liners can all be used to make drawings. All have the same single drawback – the size of the line width is fixed and cannot be varied. It is important to experiment with these types of pen to see exactly what is possible. They are excellent for hatched and cross-hatched drawings and the ink in many of them is water-based making it possible to lighten lines and pull out tone by working into the drawing with a brush and water.

PAPER and SUPPORTS It is wise to match the support to the media being used, as some papers are better suited to working with certain media. There are three distinct paper surfaces. Rough, as the name suggests, has a random, textured, pitted surface. It is best suited to bolder work using charcoal, chalks, pastel pencils, soft graphite sticks or pencils.

Papers with a smooth surface are known as "hot pressed". They are ideal for pen and ink work, wash drawing and fine pencil work.

Papers with a medium surface are known as "cold pressed" or "NOT", because they are not hot pressed. Papers in this group take most media reasonably well and are the easiest to use.

Most drawing papers are white but coloured papers are available and are ideal for pastel, chalk and charcoal work.

The majority of the demonstrations in this book have been drawn on cartridge (standard drawing) paper.

DRAWING BOARDS and EASELS You will find it easier to work if you secure your paper or support to a drawing board. You may initially work with your drawing board propped on a few books but eventually you will need an easel. A good choice for the beginner, which combines both of these considerations, is an adjustable table easel.

Basic Techniques

This section shows, in a simple, graphic way, all of the techniques used in each of the drawing demonstrations. It explains how and when each is used and what drawing implements can be used to make them. These techniques can be practised in isolation without making a drawing. This can be beneficial as it will make you familiar with that technique and this can be a useful exercise in order to loosen up before starting work. This section also outlines fundamentals like simple perspective, drawing ellipses and composition, how to simplify the subject and measuring and judging proportion. There are also tips on setting up and starting work.

LINE Line is usually used to show the shape of an object, but by varying the quality of the line it can be used to show a lot more, including light and shade. The most adaptable and expressive materials are those that will create a line varying in both thickness and density. These include charcoal, conté, pastel and graphite. Graphite sticks, as used here, are especially useful and have an advantage over the wooden pencil. Being a solid strip of graphite, the entire sharpened point can be used to create a line which can change from very thick to very thin and very light to very dark, in one fluid stroke. This is done by altering the angle of presentation so that more or less of the graphite is brought into contact with the support.

LINE

EXPLOITING THE SHAPE OF THE TOOL
Drawing tools which consist of solid pigment – such as conté chalks, pastels, charcoal and graphite – can make a range of marks simply by altering the way the tool is held and brought into contact with the support. Here, a square of black conté chalk is used to make five different marks. The first is made by using the stick on end to make a mark the width of the stick which should be a consistent width regardless of the mark's length. The second mark is made by using the stick on one of its edges; this mark will vary in width as the stick wears. The next mark is made by placing the stick lengthways on the support and pulling against its full length. The fourth is made by using the stick on end to begin the mark but turning it as the stroke progresses. The last mark is made by using a sharp corner of the stick; as the stick wears the mark will become thicker. All of these marks can be made lighter or darker by applying more or less pressure.

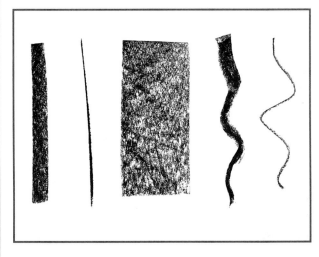

SHAPE OF THE TOOL

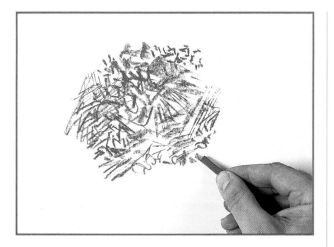

TEXTURAL MARKS

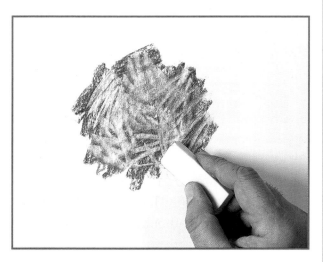

ERASERS

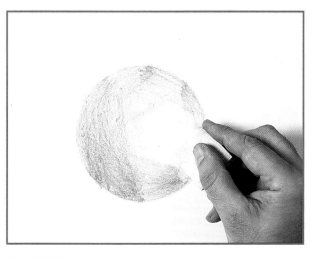

HIGHLIGHTS

TEXTURAL MARKS Textural marks are used to describe different surface characteristics and structure. All drawing tools will make a surprisingly wide range of textural marks. Textural marks are harder to make with pen and ink, but artists are inventive creatures and much can be done by utilizing brushes and sponges. The widest range of marks are made by soft pigmented drawing materials like chalks, charcoal and graphite. The range and quality of the marks can be extended yet further by using the surface characteristics of the various drawing papers available.

ERASERS Conté chalks, pastel, graphite and charcoal, together with other soft pigmented drawing materials, are especially receptive to being worked into with erasers. Harder plastic and vinyl erasers behave well with dusty materials like charcoal and conté, whereas the softer putty erasers tend to become clogged. Plastic and putty erasers work well with graphite. For cleaning up large areas use a soap gum eraser or try rubbing soft, white bread into the drawing. Surprisingly, this is amazingly effective. Erasers are excellent for making textural marks and drawing back into areas of tone.

HIGHLIGHTS Erasers are also used for creating highlights and "knocking back", or making lighter, areas of flat tone. As a general rule, putty erasers make softer marks whilst vinyl and plastic erasers make cleaner or harder marks. The erasers will get dirty quickly, especially when using them with charcoal. To make your erasers last longer, cut off a piece just large enough to do the job in hand. If this becomes too dirty it can be discarded and another piece cut.

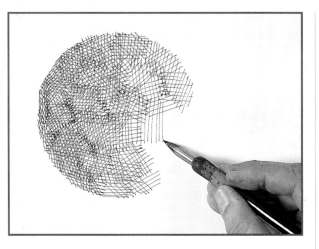

TONE/HATCHING

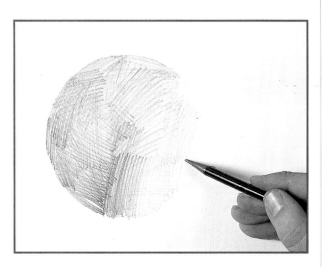

TONE/SCRIBBLING

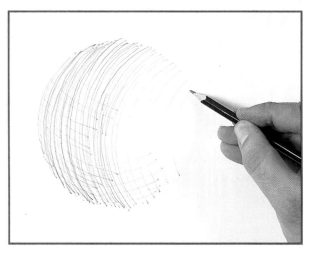

TONE/BRACELET SHADING

TONE/HATCHING Hatching is a method of applying tone using a series of parallel lines. Cross-hatching also uses parallel lines, but blocks of these are made to run at an angle to one another. Tones are built up by varying the density of the lines. This is a favoured way of shading when using pen and ink because it uses line and is controllable. It is the best method to use when using technical pens, which deliver a standard line. The technique can be used with all media but care needs to be taken when using it over a large area as it can look mechanical.

TONE/SCRIBBLING Scribbling is both fast and efficient. It is possible, with practice, to quickly cover large areas with uniform tone or apply graded tones which run from pale grey to dense black. The best tools for applying scribbled tone are pencils, graphite sticks and conté or artists' pencils. The most suitable colours to use are black or one of the traditional colours; terracotta for example. For lighter tones hold the tool lightly high up its shaft. For darker tones apply heavier pressure whilst holding the tool nearer the point. Varying the direction of the strokes ensures that the viewer's eyes are not pulled in only one direction.

TONE/BRACELET SHADING Bracelet shading uses a series of parallel lines which follow the shape or contours of the object. Variation and tone is made by making the contour lines closer together or by varying their thickness and density. Because of its linear qualities this technique is especially suited to pen and ink. The technique has limitations when used on its own, but can be combined with hatching or cross-hatching.

TONE/STIPPLING Stippled tone can be made with all drawing media. Tone is built up by varying the density or the size of the stippled marks. These marks usually consist of dots or dashes or a combination of the two. Stippling with pen and ink or pencil can be a slow process. You will work faster with pastel or charcoal. Stippling does not have to be used in isolation but can be combined with other shading techniques.

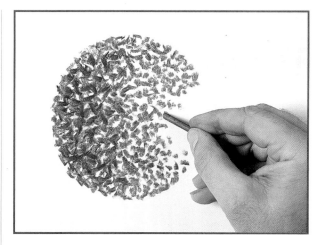

TONE/STIPPLING

TONE/BLENDING Perhaps the most familiar way of achieving a transition from light to dark tone is by the use of blending; whereby tone is manipulated by smudging or rubbing. This type of blending can only be done with materials that leave a dusty, pigmented residue on the support, like pastel, conté, charcoal or graphite. The softer the material the easier it will be to blend. Blending can be done using a tortillion or paper stump, rag, paper towel, tissue or the finger. Blending can be over-done, softening the drawing so that it becomes bland and lacking in any "bite" or vitality.

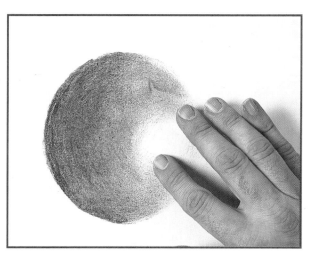

TONE/BLENDING

TONE/WASH Ink and watercolour are used in the same way. The colours are mixed with water to create thin, tonal washes. When applied these washes allow light to reflect back off the support. To make a colour lighter more water is added; to make a colour darker more pigment. The washes can be blended "wet into wet" or allowed to dry and applied one over the other, "wet on dry", so that the tones and colours are built up. Paper is usually white, so any white highlights are left free of any washes. This requires pre-planning to ensure these areas are not accidentally covered in ink or paint.

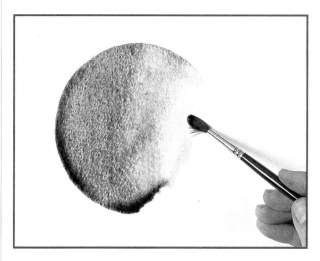

TONE/WASH

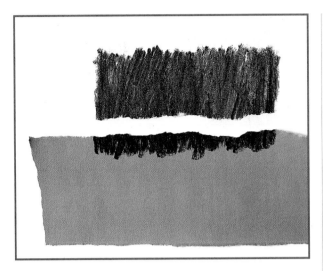

MASKING

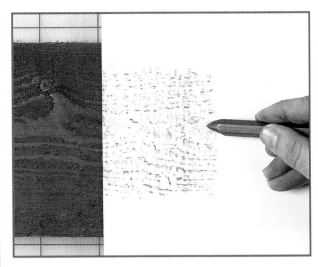

FROTTAGE

MASKING Masking is a technique usually associated with painting, however, it is just as useful when used with drawing materials. On a drawing it is not used to prevent marks straying into areas where they are not wanted, but rather to give a distinct edge quality to an area of tone or texture. Scribbling tone up to a complex or even a straight edge requires control and takes time. By using a mask made from either torn or cut paper or, when working up to a straight edge, a ruler, not only saves time but leaves a crisp, sharp edge. Care needs to be taken to hold the mask firmly in place, if it slips or moves the effect will be lost.

FROTTAGE From the French *frotter* which means "to rub or scrape". The technique requires the drawing implement to be rubbed over the paper's surface, which in turn has been placed over a firm, textured surface like a rough wooden board or corrugated cardboard. The pigment from the drawing tool takes only to the places where the texture touches the paper, leaving an image of the texture to show through. The technique only works with relatively pronounced textures and will not work on thick papers.

COMPOSITION/RULE OF THIRDS
Composition is the way you arrange your subject and how all of the negative and positive elements within the picture area work and interact with one another. It is important as it determines how the viewer's eye will be led into and around the drawing. Colour, size, space, form and texture all play an important part in achieving compositional balance and need to be given equal consideration. In order to achieve this, certain formulae have been established which divide the picture area up into an invisible grid upon which the main elements are positioned or arranged. One of the most basic and adaptable is the so-called "rule of thirds" where elements of your subject are placed on or about these invisible lines and their intersections. The rule invariably works but we all know rules are made to be broken and drawings are often more exciting to look at when compositional risks are taken.

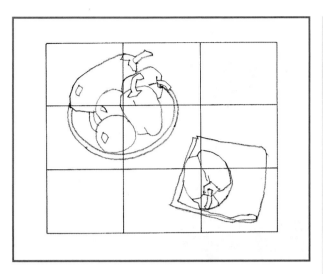

COMPOSITION/RULE OF THIRDS

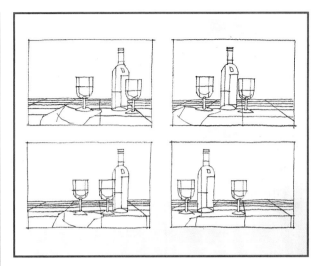

THUMBNAILS

THUMBNAILS Thumbnails are small rough or loose sketches which are made prior to beginning a drawing proper. They give the artist the chance to work out and consider several options before committing to one. One of the main options given consideration in thumbnails is composition; several different alternatives can be looked at and the best chosen. Making thumbnails is also good drawing practice, giving you a chance to explore not only the subject but also the material being used.

SIMPLIFYING SHAPES The shape of all objects, no matter how complex or intricate, can be represented by a series of simple circles, cones, cylinders, boxes or other simple geometric shapes. Doing this allows you to sketch out the arrangement with some accuracy so that objects are made to fill their space and stand correctly in size, proportion and position in relation to one another, prior to making the drawing. Concentrating on intricate nuances in shape, colour or texture can prevent you from drawing the underlying structure and shape

of a thing correctly. Perhaps the most useful advantage of using this technique is that it allows perspectives to be seen more clearly, which in turn allows cylindrical objects and ellipses to be drawn correctly.

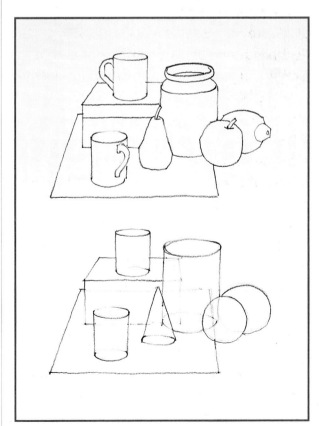

SIMPLIFYING SHAPES

SIMPLE PERSPECTIVE The laws of perspective dictate that all parallel lines on any plane or surface, other than a surface seen straight or flat on, meet at the vanishing point. In simple one- and two-point perspective this point falls on the horizon line. The horizon line runs horizontally across the angle of view at the artist's eye-level. Lines drawn above the horizon line run down to meet it; lines drawn below run up to meet it. In the diagram a cube is shown in perspective from three angles. The top-left cube is drawn from slightly above but straight on, so that neither side can be seen. The top-right diagram shows the cube again seen from slightly above but from an angle so that two sides can be seen. The bottom diagram shows the cube drawn at an angle but at eye-level.

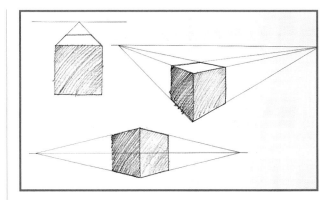

SIMPLE PERSPECTIVE

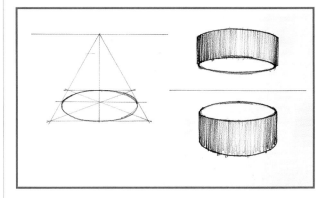

DRAWING ELLIPSES

DRAWING ELLIPSES Any cylindrical object seen from directly above looks circular, but viewed from an angle, in perspective, it looks elliptical. The diagram shows the principle of drawing ellipses in perspective. To check if a drawn ellipse is correct, look at it upside down, when any inconsistencies in its shape will become obvious. The ellipse seen at the top and bottom of a cylindrical object will be different because of the angle of view in relation to the eye-level or horizon line.

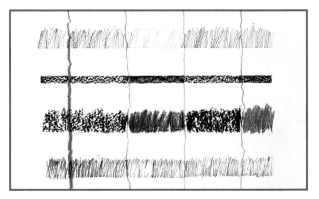

USING DIFFERENT PAPERS

USING DIFFERENT PAPERS The drawing paper should be chosen so that its qualities match those of your drawing material. As a general rule, pen and ink drawings are better made on a support with a relatively smooth surface, however coarser bamboo pens work very well on rough papers. Pastel pencils and charcoal need a support with some degree of texture on to which the pigment dust can cling. On smooth paper charcoal tends to slide around and you will find it impossible to build up areas of very dark tone or make solid black lines. In the illustration notice how the qualities of the four different drawing materials are affected when used on five different papers.

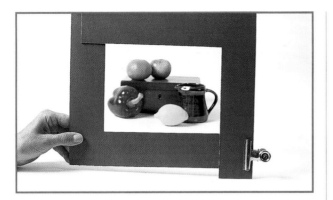

USING A VIEWFINDER

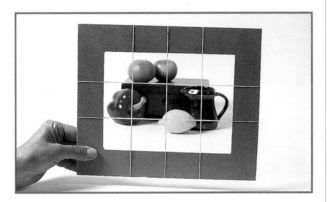

USING A GRID

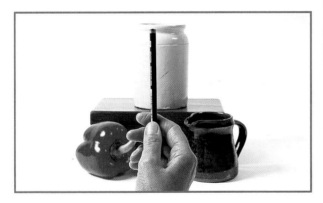

MEASURING

USING A VIEWFINDER One of the first things you need to consider is the format of your drawing. Traditionally there are two formats, both based on the rectangle. When the longest side of the rectangle runs vertically the format is known as "portrait". When the longest side of the rectangle runs horizontally the format is known as "landscape". Both formats are used in still-life drawing and a homemade framing or viewing device will help you decide which format to use. Cut two "L" shapes out of a piece of dark card and use two clips to hold them together. The length to width ratio of the viewing frame can be altered by adjusting the "L" shapes.

USING A GRID Using a grid will enable you to roughly plot out your drawing. Cut a rectangle out of a thick piece of card. Over this stretch elastic bands so that they form the grid. Draw the same grid lightly onto your support; this can be any size as long as it is in proportion to the grid made by the bands. Hold the grid up, look through it at and plot out what you see onto the support, over the grid of lines you drew earlier. Unless the grid and your head are held in the same position you will find it impossible to draw with any detail what appears in each square but it will allow you to judge the relative proportion and position of things.

MEASURING This technique can be used in tandem with the grid technique. Hold the pencil out at arms length and slide the thumb up the shaft of the pencil to take the measurement. The measurement being made here is from the top of the jar to its base. This measurement is then used to compare the size and position of the other elements in the set-up. In this set-up the distance from the back edge of the box to the base of the red pepper and from the back edge of the box to the base of the jug are almost the same as that of the jar. Several different measurements can be made and each used in the same way.

Demonstration 1

Fruit *Graphite pencil*

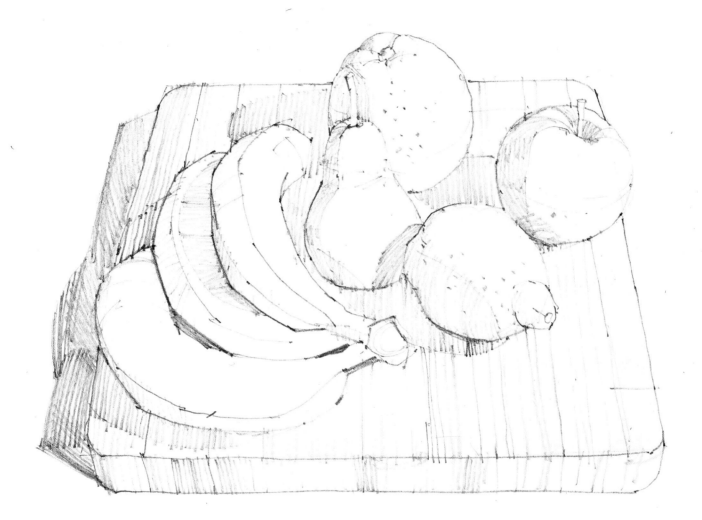

Although relatively simple, this drawing conveys what can be achieved by working in line only with one soft graphite pencil. The hard straight lines of the wooden block contrast with the softer flowing curves of the fruit, giving adequate opportunity to use a range of different linear marks. The shape and angle of the block not only contains and frames all of the elements but also adds depth and perspective to the drawing.

Most drawing materials or tools make linear marks much more easily than they make areas of tone; indeed the word "drawing" is immediately associated with

line. In reality, lines do not exist; as made by the artist they are simply a graphic device to show the extent or shape of a thing. Put another way, they indicate that position in space where one thing ends and another begins.

Regardless of the drawing materials being used, a simple line can show a great deal more than just the shape of something. Lines can be made thick or thin, heavy or feint, continuous or broken – all of which help to describe not only the shape of something but the quality and degree of light falling on it or its surface qualities and texture.

An illusion of the form or solidity of a thing can be further enhanced and described by using a device known as contour lines. Unlike those lines which describe the external shape of a thing, contour lines show the internal shape by following and describing the direction or angle of a flat or curved surface.

Subject

This project primarily explores the potential of the simple pencil line. I have chosen to draw a few pieces of fruit as most fruits have a relatively uncomplicated, rounded, fluid shape with little in the way of extreme surface textures. This makes them an ideal subject for practising line work.

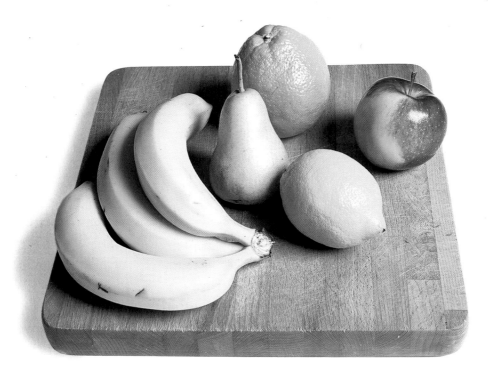

Materials

3B pencil

Sheet of cartridge (drawing) paper
594 x 420mm (16½ x 23½in)

1 Arrange the fruit on a square wooden chopping block. This has the effect of holding the image together, with the shape of the block acting as a well defined area into which each piece of fruit is positioned and related. Begin by lightly indicating the shape and position of the board. Pay particular attention to correctly positioning the angle of the lines that represent the right- and left-hand sides of the block. Onto this, lightly indicate the simple shape and position of the fruit. Once you are happy with this positioning, use these light lines as a guide and redraw the edge of the block and its shadow with a darker line by applying heavier pressure to the pencil.

2 Draw the bananas next. Although they appear to be gently curved in shape, the line describing their shape should search out and show each slight change in direction. Note how one of the bananas intersects or overhangs the edge of the wooden block. Use a darker or heavier line on the side of the banana in shadow and draw a lighter line on the side receiving light. The angled sections, which make up the sides of the banana, should be indicated using light lines.

3 The pear and lemon are drawn in the same way. As you are drawing pay attention not only to the shape of each piece of fruit but also to the shapes created around and between them, relating their shape and position to the bananas and the edge of the block. These shapes around an object are known as negative shapes and are as important as the object itself or the so-called positive shapes. Negative shapes not only enable the accuracy of a drawing to be checked, they also act as a balance to the positive shapes and are an important part of the composition.

4 Draw the orange and the apple. As before, vary the pressure as you draw the lines; apply less pressure on the lit side of an object and heavier pressure on the side in shadow. Pay particular attention to the stem or the area where each piece of fruit was attached to its parent plant and notice the degree to which each piece of fruit dissects the edge of the wooden block.

5 Use a few light lines to describe the position where the shadows fall on both the wooden block and each piece of fruit. Also use light lines to describe the contours of each piece. These should not be overdone – two or three lines for each piece of fruit is enough. Add lines to indicate each section of wood making up the wooden block.

Artist's tip
Before you begin drawing in earnest, you should always position the main elements of the subject on the support by making a very light, loose sketch. This then acts as a guide and can be worked over with much darker line work.

6 Add more lines to the block to suggest the pattern of the wood grain. Make these lines darker in areas of shadow and on the block edge. This has the overall effect of throwing the fruit, which tonally is much lighter, into relief.

7 Although essentially a line drawing, complete the work by adding a little simple tone to those areas in deep shadow. Apply the tone using a series of simple lines, following the shape or contour of each surface.

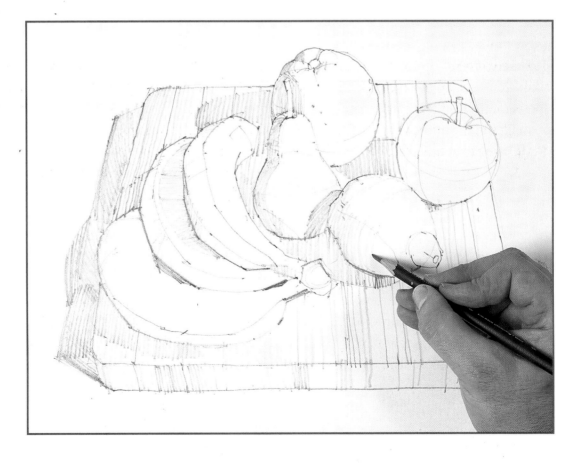

TRY A DIFFERENT ...

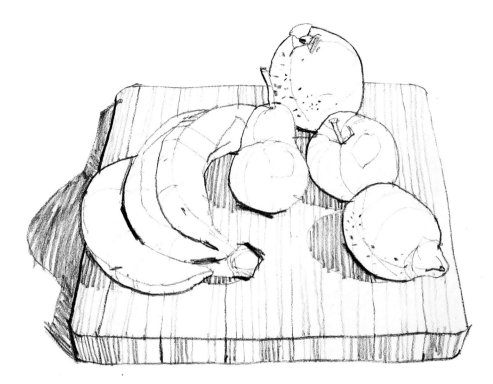

... MEDIUM

I drew the set-up for a second time using a stick of medium charcoal. The lemon was moved over to the right-hand side of the block for this drawing but the set-up stayed essentially the same and the drawing was made in much the same way. The very nature of charcoal requires a direct and broader approach. Although not always easy to use and by no means as familiar to the novice as the pencil, it is an ideal medium to use when learning how to draw. Charcoal gives a dense, sensual, easy line and the material needs to be used with confidence in order to give of its true potential.

... ARRANGEMENT

The possible variations of a simple arrangement are almost limitless. Experiment with the composition by adding or removing elements, or by introducing new elements outside the "frame" created by the wooden block.

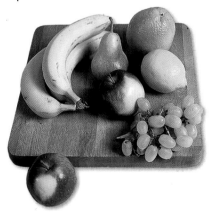

Demonstration 2

Hard Objects *Graphite pencil*

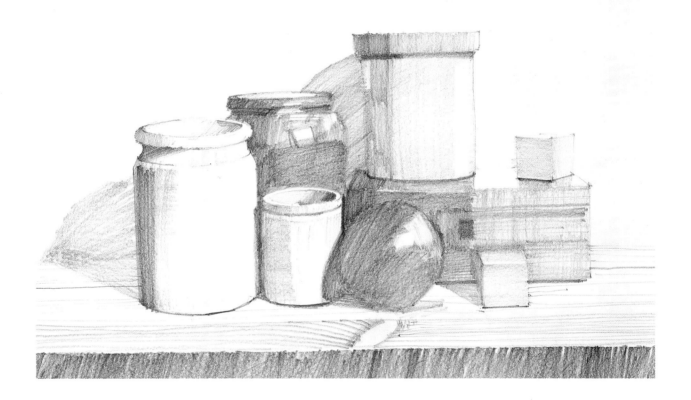

Tone, or shading, indicates the form or shape of an object. It is important to learn how to convincingly represent tone in order to give your two-dimensional drawing the appearance of having three dimensions – height, width and depth. Tone is defined by the quality, quantity and direction of the light falling on an object. It is also influenced by the colour, texture and any pattern present on that object. The easiest way to understand tone is to look at a black and white photograph. You will see how everything can be given what is known as a tonal value. These values run from white, through all the shades of grey, to black.

Used well, tone can also convey mood and atmosphere. There are several different shading techniques and, whilst most of them can be used with several different media, some are best suited to specific media and it pays to match the technique with the drawing materials being used.

Graphite is perhaps one of the easiest materials to render tone with. By varying the pressure applied when using a soft pencil, a full range of tones – from very pale grey to dense black – can be made. You will find that a light tone is easier to make if you hold your pencil lightly, high up the shaft, whilst a dense, dark grey or black requires you to hold the pencil nearer the point. With practice, it is possible to vary your grip and the pressure applied without it being necessary to stop drawing. You can practise this on a piece of scrap paper. Remember that it is easier to make a tone darker than it is to make it lighter, so always build your tone from light to dark.

Subject

This still life has been set up using a collection of objects that can be found around most homes. The shapes are relatively simple, as are the ellipses and perspective on the box and bricks. With a single, strong light source coming from the right, the shapes of the objects are evident and should be relatively straightforward to represent.

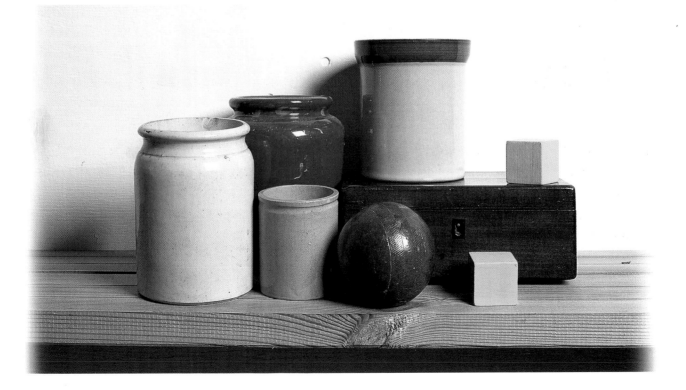

Materials

2B and 6B pencils

*Sheet of cartridge
(drawing) paper
594 x 420mm
(16½ x 23½in)*

Ruler

Putty eraser

1 Using the 2B pencil, sketch in the position of the objects. Work lightly so that the lines will disappear once tone is added. Notice how the jars and pots are little more than simple cylinders; concentrate on getting the shallow ellipses at the top and bottom of each of them correct. The wooden ball is simply a circle. Draw in the box and bricks using one- and two-point perspective. Once you are happy with the position and shape of the objects, begin to work the middle tones seen on the left-hand jar. In order to make the tone darker, apply heavier pressure to the pencil.

2 Use a darker tone to block in the shaped vase at the back. Press hard to make the dark tone between the left-hand jar and the small pot at the front. Light pressure establishes the overall tone of the small pot with slightly heavier pressure giving the shadow inside, around the rim and the shadow cast by the wooden ball.

Artist's tip
Take care not to make your initial line work too dark. It should serve only as a guide and should not be noticeable once the tone is applied.

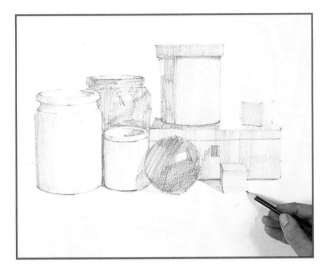

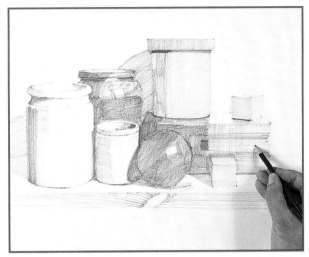

3 Scribble a relatively dark tone evenly across the wooden ball and apply a slightly lighter tone across the front of the wooden box. Work a similar tone onto the earthenware jar sitting on top of the box. Darken the rim of this jar and add a dark area to the jar's left-hand side and the top of the box immediately below the jar. Treat the small bricks next with a light tone applied to the side facing the light and a mid-tone on the forward-facing side. Indicate the lid of the box and the shadow beneath it with a dark line.

4 Establish the shadow tone seen on the wall behind the objects, followed by the linear pattern of the wood grain along the edge of the shelf. Change to the 6B pencil and darken the shaped vase at the back. Darken the shadow side of the left-hand pot and the wooden ball and its cast shadow. Darken the left-hand side of the box and the top of the box immediately beneath the shadow on the earthenware pot sitting on top of it. Add a little shadow beneath the brick with a dark line and describe the wood grain on the front of the box.

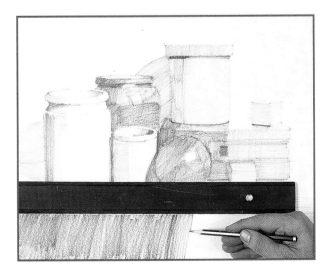

5 Use the 6B pencil to scribble in the very dark shade beneath the shelf. A quick and easy way to do this is to use the straight edge of a ruler as a mask. Hold this down on the paper, support with one hand, whilst using the pencil with the other to scribble up to it. Notice how once the mask is removed the quality of the dark edge which is left has a pleasant crispness to it.

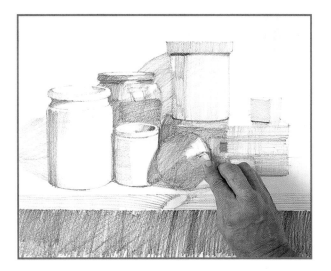

6 At this point any highlights or lightening of tone can be made by using a piece of soft putty eraser. It is always easier to darken an area of tone than it is to lighten it, so try not to over-darken tone and always judge an area against the one next to it. Graphite makes erasers dirty very quickly and they will last longer if pieces are cut off them as and when needed.

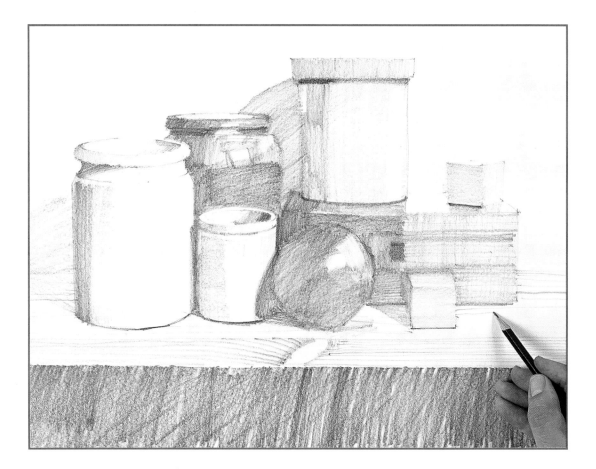

7 Look at the drawing carefully and reassess the tones – lightening or darkening those that seem wrong. Try not to be too critical; remember it is a drawing not a photographic representation. If it reads correctly, with each object looking as if it occupies its own space convincingly, then the drawing has been a success. Complete the work by adding a little linear detail to the surface of the shelf.

TRY A DIFFERENT ...

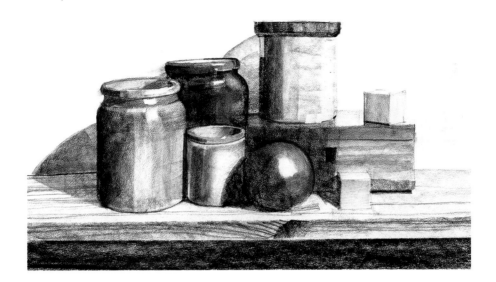

... MEDIUM

This still life was made using black and white conté chalk on a sheet of cold pressed watercolour paper. The overall look of the piece is darker than the pencil drawing. This is simply a characteristic of the drawing material used, as black conté is darker than soft pencil. However, the drawing is made in much the same way and it reads as being correct because all of the tones work relative to each other. The chalks can be broken to make short lengths; these can be used on their side to block in areas of tone very quickly.

... ARRANGEMENT

Limitless variations are possible by adding or taking away objects to make the arrangement more or less complex. This technique of making several different drawings using the same or slightly different objects is an ideal way to learn about space, balance and composition as you will soon begin to assess those arrangements which feel right and those which look awkward.

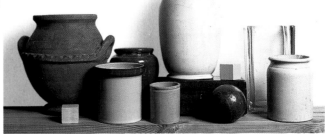

Demonstration 3

Natural Objects
Graphite sticks and powder

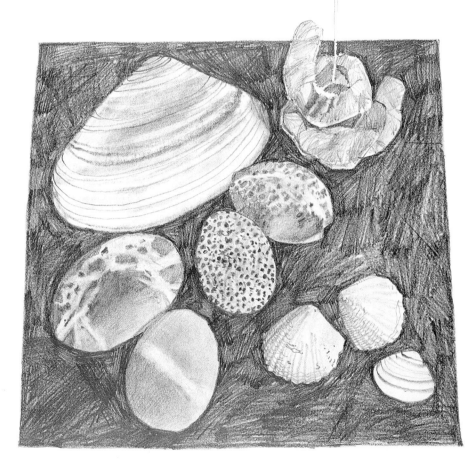

Whilst tone describes the shape or form of an object, it is texture which describes the characteristics of an object's surface. Every surface has a texture – be it the smoothness of glass and ceramic, the roughness of wood or the weathered, pitted surface of stone.

The artist's problem is what marks to make in order that these surface textures look convincing, whilst using exactly the same drawing material to represent both rough and smooth surfaces. Representing texture gives the artist a chance to be inventive and

dig deep into his or her repertoire of techniques in order to find one that matches the texture being drawn. An eraser is a useful tool when making textural marks as it enables the artist to work back into the graphite tone and create a range of marks, which would be difficult, if not impossible, to create in any other way.

The choice of paper or support is an important consideration. For highly textured objects with a rough, pitted surface choose a rough paper; for surfaces like glass or ceramic choose a smoother support. You should think carefully about what you are drawing and choose a support which has a surface that is sympathetic to your subject.

Subject

Found stones and shells from a beach, together with a collection of seed pods, make an interesting group of natural objects requiring a number of different approaches to convincingly represent the various textures. The objects are arranged on a square sheet of black card. This serves two purposes – it isolates and shows up the shape of each object and it also acts as a frame within which the negative shapes around each object can be assessed.

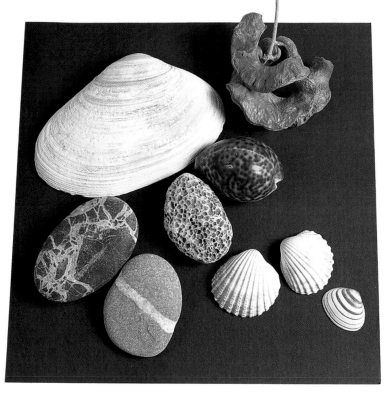

Materials

3B and 6B thin graphite sticks

Sheet of cartridge (drawing) paper 594 x 420mm (16½ x 23½in)

Graphite powder

Paper towel

Putty and plastic erasers

4B thick graphite stick

Fixative

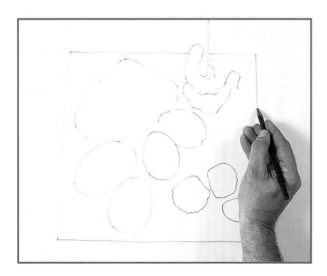

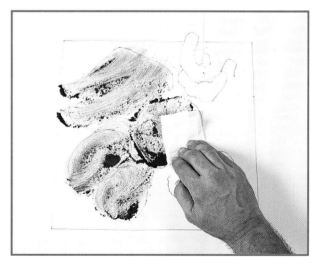

1 Using the 3B graphite stick, draw in the shape and position of each of the objects. Draw the shape of the black piece of card first, then relate the shape of each of the objects to it. As you draw, pay equal attention to the shape around the object, the negative shape, as you do to the shape of the object itself.

2 Tone is added to the objects by pouring on a little graphite powder. Rub it into the paper's surface using a pad made from paper towel. You could use a paper torchon or your fingertips instead if you prefer. Dispose of the excess powder by pouring it back into its jar or bag, so that none of it is wasted.

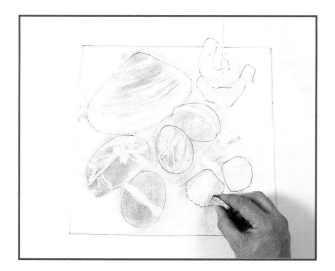

3 The remaining tone is then "drawn" into using various erasers. Make larger marks using the putty eraser and finer, linear marks using a harder, plastic eraser.

Artist's tip
In order to prevent the graphite powder being picked up or smudged by your drawing hand, rest the side of your hand on a piece of paper towel.

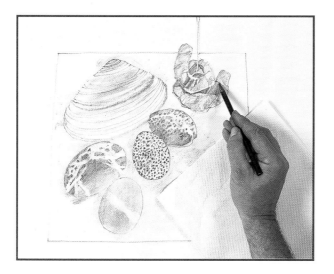

4 Using the thicker 4B graphite stick, draw in the lines which cover the surface of the large shell. Alter the thickness and quality of the lines by using not only the point of the stick, but also the side of the point. Accentuate the pattern on the stone below and draw in the markings on the smooth, shiny surface of the cowrie shell on the right. The stone below the cowrie has a pitted surface which requires a heavier mark, made by stabbing the graphite stick at the support.

5 Use the thin 3B graphite stick to draw in the texture and pattern of lines on the seed-pods. These need careful exploration using varying degrees of tone to search out and describe their curly shape.

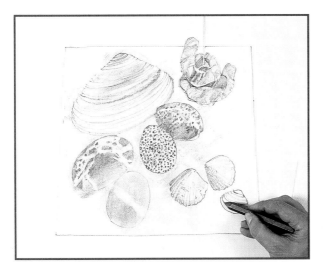

6 Use the thicker graphite stick again when drawing in the pattern on the smaller shells. Notice how it is not necessary to draw in all of the pattern, but just a little on the side, away from the light source. A series of thick and thin lines complete the small clam shell in the lower right-hand corner.

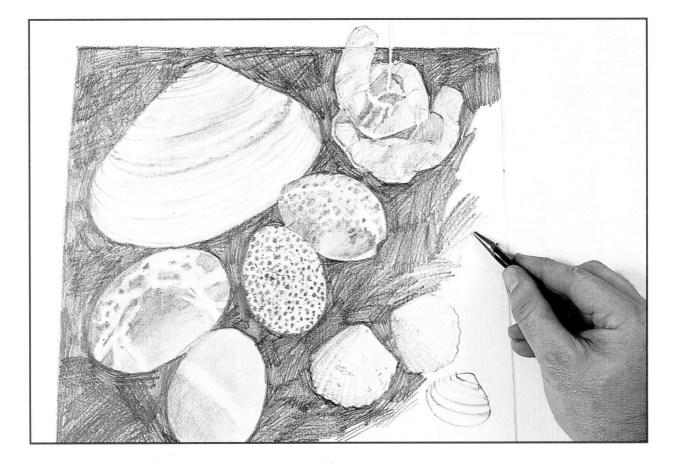

7 Complete the drawing using the 6B stick by scribbling in the darkest tone representing the square of cardboard on which the objects sit. This is an opportunity to redefine the shape of the objects. Vary the direction of the graphite marks as you work. Notice how the objects suddenly gain depth and dimension as the dark tone is worked around them. To prevent your finished piece from getting smudged, spray with fixative.

TRY A DIFFERENT ...

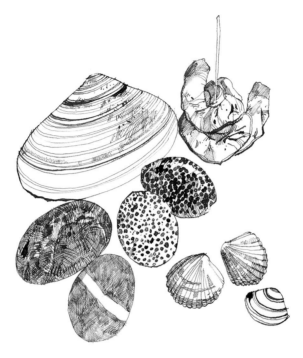

... MEDIUM

Exactly the same arrangement has been used in this drawing except it is on a light background. Ink and a dip pen were the materials used. This is essentially a linear medium, with any representations of tone being made by using a series of hatched and cross-hatched lines. Line density and width is varied by pressing harder on the pen; this splays the two sides of the steel nib, allowing more ink to be left on the paper.

... ARRANGEMENT

This arrangement consists of several sea shells of varying shapes and sizes. Placed on a white background and without the dark square of card behind, there is no frame or point of reference to refer to when drawing the shapes. Each shell needs to be drawn in relation to the ones next to it and, as before, careful attention paid to the negative spaces between and around the objects.

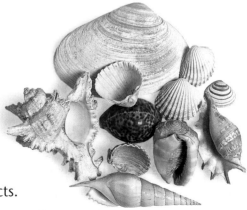

Demonstration 4

Garden Tools *Charcoal*

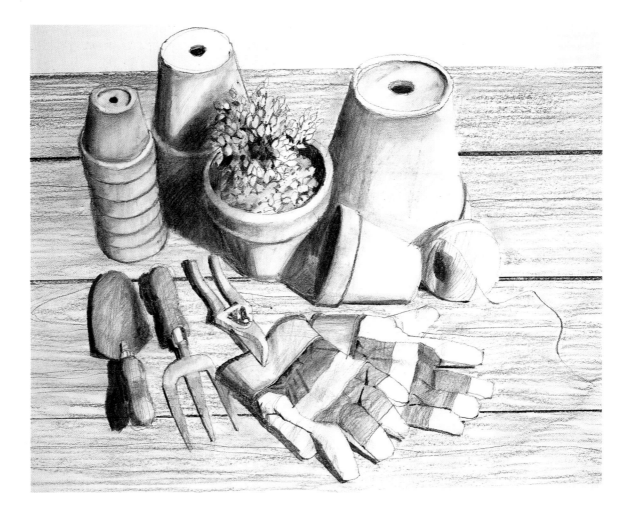

Despite being the most basic of drawing materials, charcoal can, with practice, produce very sophisticated drawings. It is a favoured material for teaching drawing as its characteristics force a broader approach – try making a charcoal drawing which concentrates on minutiae and detail and you will fail. Charcoal drawings need to be relatively large as this allows the freedom to manipulate the charcoal on the support surface. It is a fast medium; the marks are dark and positive, which can be off-putting for the beginner, but most artists soon come to enjoy working with it.

Charcoal drawings smudge easily so to prevent your finished piece from being spoiled, it needs to be fixed; either at intervals as the work progresses or when the work is complete. However, this characteristic enables corrections to be easily made. Brushing over the area to be corrected with a stiff brush or flicking lightly with a clean rag easily removes the charcoal dust leaving the faint remains of the image, which act as a guide when you redraw. When visible in the final drawing, these corrected marks are known as *pentimenti*, which comes from the Italian meaning "contrition" or "repentance".

Using an eraser on charcoal drawings is not recommended as they tend to smear and push the charcoal dust into the support surface rather than remove it.

Subject

A few items from the garden shed form the basis of this still life. The qualities of the drawing material perfectly match the earthiness and simple shapes seen in the subject and give ample opportunity to explore the material's potential. Notice the composition; the items are arranged in such a way as to keep the eyes moving over and around the scene in a circular motion.

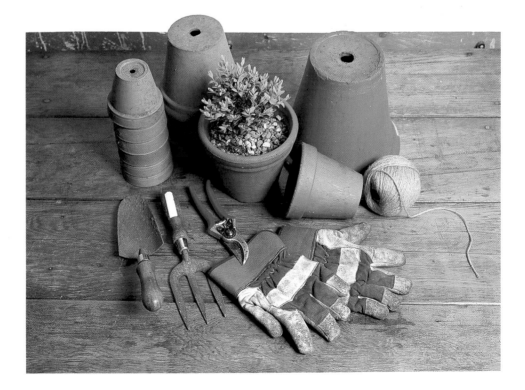

Materials

Soft and hard charcoal pencil

Sheet of cartridge (drawing) paper 598 x 840mm (23½ x 33in)

Large soft brush or soft rag

Stick charcoal

Paper torchon

Fixative

Ruler

1 Use the soft charcoal pencil to sketch in the objects. Ignore detail and concentrate on shape and position. Pay attention to the ellipses on the flower pots and the angle of the fork and trowel. Once you are happy with the positioning, lighten the line work by brushing off any excess charcoal dust using the soft brush or rag.

2 Use the stick charcoal to establish the darkest tones in the shadow areas of the drawing. You will find that a point is reached where it becomes impossible, even by pressing harder, to make an area of tone any darker. This is because the paper surface can only hold a certain amount of loose pastel dust.

3 Using the paper torchon, pick up the excess charcoal dust and rub it into the support surface to establish the mid-tones. Work across and around the flower pots, over the tools and onto the fabric of the gardening gloves. Occasionally you may find that you need to reintroduce more depth into the darker areas using the stick charcoal.

4 Once the medium tones have been established the work can be fixed. Fixing before this point would mean that the charcoal cannot be manipulated and moved around using the torchon. Once fixed, use the stick charcoal to restate those areas in deep shadow and begin to define the leaves on the plant.

5 Once you have completed all of the tonal blocking you can begin to add some detail. Use a combination of hard and soft charcoal pencils to draw in the leaves on the plant and the gravel dressing in the pot. Add dark reflections into the chrome on the tool handles and define the cutting blades and the mechanism on the secateurs. Establish the twine on the ball of string and rework the seams and material on the gardening gloves.

6 Block in the wood grain of the tabletop using a piece of stick charcoal placed on its side and pulled horizontally across the support, working around and between the objects.

7 Draw in the dark gaps between the wooden planks which make up the tabletop by using the stick charcoal and a ruler. Add the final touches using the soft charcoal pencil; draw in a few finer lines across the tabletop. When complete, fix the drawing to prevent smudging.

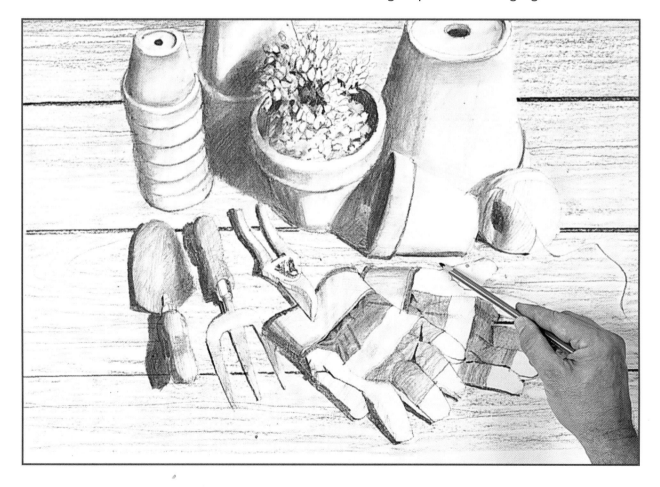

TRY A DIFFERENT ...

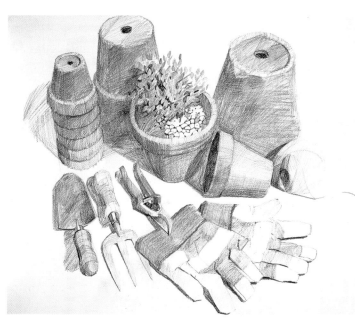

... MEDIUM

I drew the same set-up using coloured pencil which is essentially a linear material and cannot be blended. The drawing was made on NOT (cold pressed) surface watercolour paper, which picks up and holds the colour well. The image was built up by scribbling one colour over another, working in layers until the desired tones and colours were achieved.

... ARRANGEMENT

A more complex composition can be made by introducing other objects into the set-up, lowering the angle of view and piling one thing on top of another. This makes it more difficult to draw the objects so that each convincingly occupies its correct position in space.

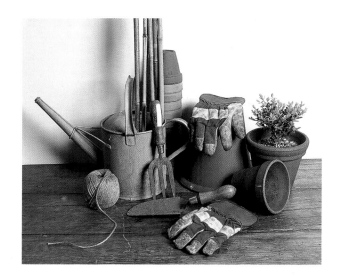

Demonstration 5

Fabric *Charcoal and white chalk*

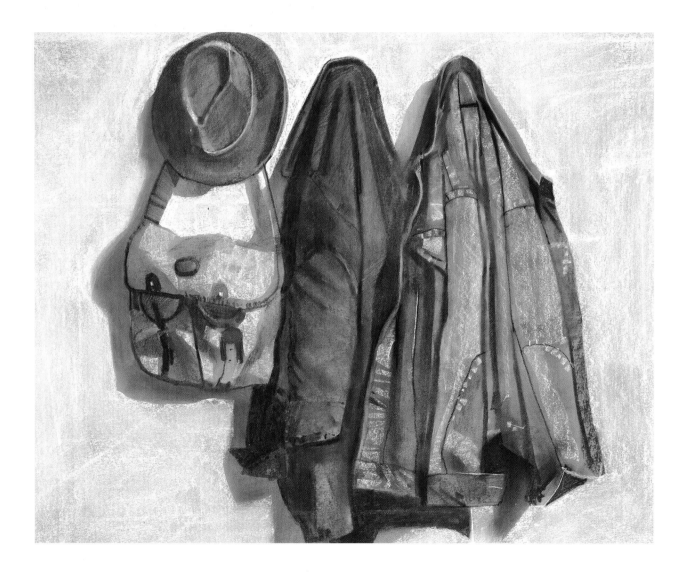

When making a tonal drawing it can sometimes seem that an inordinate amount of time is spent building up tone and obliterating the white of the paper support. Whilst most drawings are made on a white support it is easier – particularly for a beginner – to balance tones when working on a tinted or toned ground. This technique is traditional and has been in use since the Renaissance, not only as a device for tonal

drawing but also as an aid to the mixing of the correct tone and colour when painting. The choice of colour is personal, but it is important to give consideration to what effect the colour will have on the mood of the piece. Obviously it depends on the subject matter of your drawing, but generally, the more sombre greys and earth colours are perhaps better choices than those that are brighter or more strident.

The most practical tone to use is a mid-tone, balanced somewhere between black and white. If you do not have a sheet of grey toned paper it is easy to prepare your own. Rub charcoal or graphite powder into the surface of a sheet of white paper using a clean rag and spray with fixative. The ground could be left unfixed, which would allow lighter tones to be lifted out using an eraser.

For drawings like this use a paper which has a sufficient tooth or texture to hold the large amount of charcoal and chalk dust which is generated. Remember to fix your work at regular intervals as this will allow more chalk and charcoal to be built up in layers.

Subject

Fabric and drapery are a traditional subject either used in isolation or combined with other objects. Here, the various coats and hats seen hanging in almost every home make a terrific subject which often needs little or no arranging and give a contemporary twist on a well used motif.

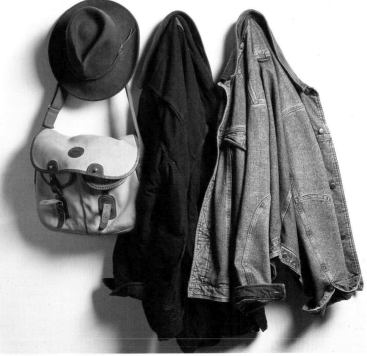

Materials

Charcoal pencil

Stick charcoal

*Sheet of mid-grey pastel paper
590 x 840mm (23½ x 33in)*

Paper torchon or paper towel

Fixative

White conté chalk

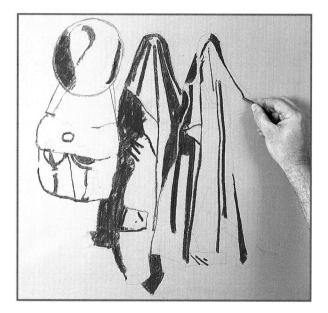

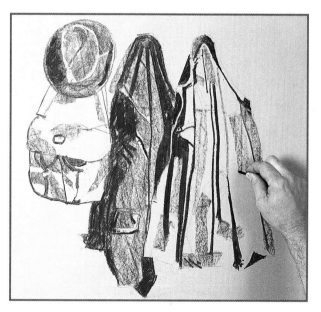

1 Use either the charcoal pencil or a piece of stick charcoal to sketch in the position and general shape of the hat, bag and two jackets. Work fairly lightly, although any obvious lines will be covered by subsequent work. Then, using the stick charcoal, loosely establish the very darkest areas of tone on each item.

2 Using a straight piece of stick charcoal on its side, make large steady strokes to block in and establish the darker mid-tones. Work carefully making sure that the strokes made follow the contours of the fabric.

3 Use your fingers to blend the dark and mid-tones together. Again, take care to follow the contours of the fabric and avoid overworking. Your fingers will get very dirty and you may prefer to spread the charcoal by using a torchon or a piece of paper towel.

Artist's tip
When making darker or heavier marks with charcoal, hold the stick close to the end making the mark otherwise the stick will shatter and break.

4 Once the tone has been spread over the hat, bag and jackets, use the excess to create the shadow tone on the left and below each item. This has the effect of visually lifting the hat, bag and jackets away from the wall, giving an immediate sense of depth. Use the stick charcoal to restate and darken those areas and folds on the jackets in deep shadow.

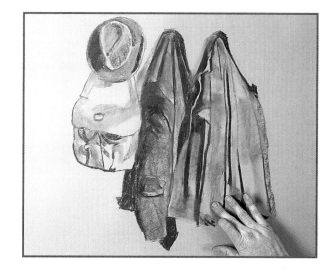

5 At this point the drawing can be given a coat of fixative. When dry, use a charcoal pencil to add detail to the jacket seams. Use the sharp corner of a square white conté chalk to draw in the highlight around the hat band and on the shoulder strap of the bag. Continue to use the white chalk to block in the lighter passages on the hat, bag and both jackets. Use the chalk on edge to cover large areas and on end for smaller areas around and along the jacket seams. Think carefully before making each mark and follow the contours and fall of the fabric as you refine the shapes.

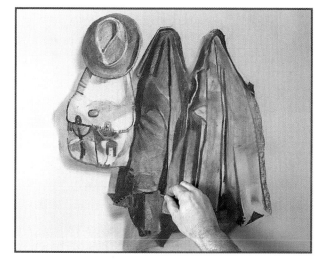

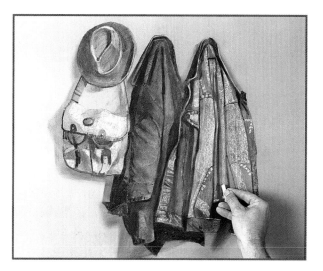

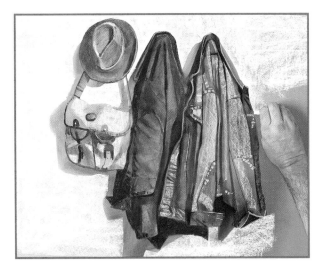

6 The light background tone is blocked in using the white conté chalk on its edge and with a degree of pressure. Work carefully around each of the items and the cast shadows, restating the shape of each as you go. Do not be concerned if, as here, the chalk picks up on the rough textures of the drawing board beneath the support. This adds interest to what, in reality, is a relatively flat, white surface.

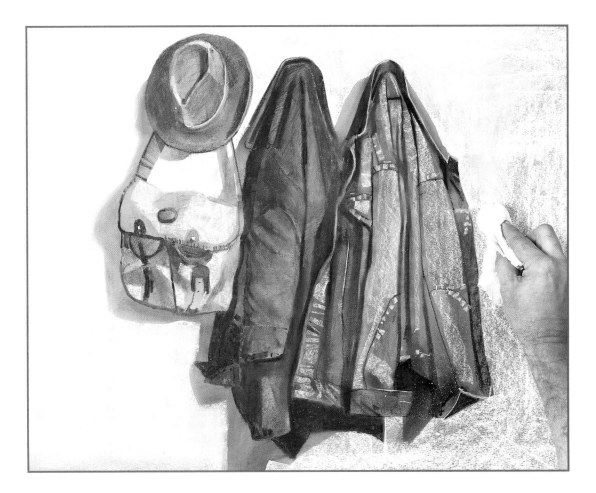

7 Once you have established the layer of white chalk rub it into the support surface by working over it with your fingers, a torchon or a pad made from paper towel.

This softens the overall effect, which contrasts with the white chalk work on the jackets and bag, which is left unblended. Once complete the drawing can be fixed.

TRY A DIFFERENT ...

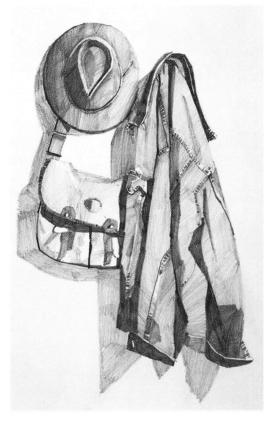

... MEDIUM

Here a hat, jacket and bag have been drawn using a single 3B graphite stick. It is a far smaller, more intimate, detailed drawing than the charcoal version. It shows the wide range of tonal values which can be achieved from one stick or pencil.

... ARRANGEMENT

By simply moving the elements around, several variations and compositions are possible, meaning that you can produce several different drawings without changing props.

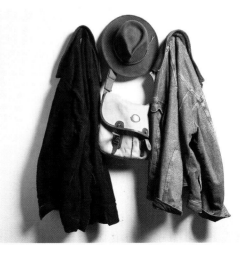

Demonstration 6

Seafood *Dip pen and ink*

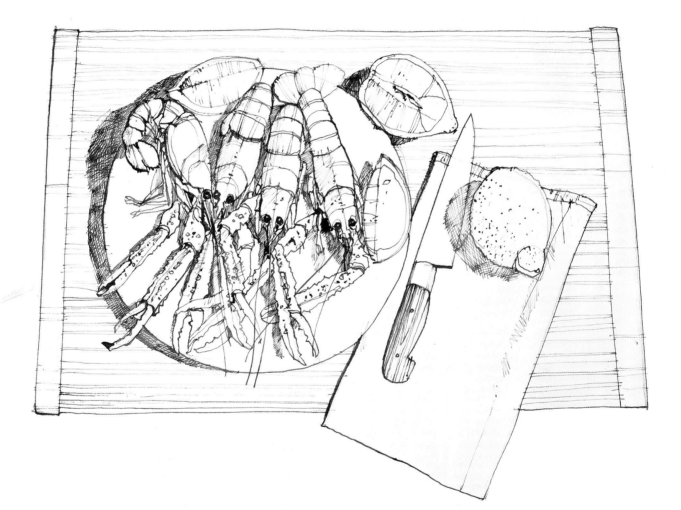

Line drawings made using pen and ink have a fine and long tradition. The material has long been popular with artists. At their best, ink drawings possess a fluid clarity. The material delivers an expressive, descriptive line quality, which is difficult to achieve with any other medium. Ink is not as easy a medium to use as pencil; it is considered to be unforgiving in so far as the marks you make are more or less unalterable. However, it is possible to make corrections by using watersoluble ink, which can be brushed over

with water and blotted off. Working on a hard surface, like a smooth illustration board, allows the dried ink to be scraped off using a sharp blade or white gouache can be used to paint out unwanted lines. All of these are best used as a last resort, as with a little forward planning most mistakes and problems can be avoided. The line quality in a drawing made using a dip pen is varied by applying different degrees of pressure to alter the "splay" of the nib. Turn the pen as you work so that the nib is used on its edge and dilute the ink with water to make it less dense.

The choice of nib that you decide to use is very important. Choosing a nib which is too thin will produce a very fine delicate line which will be difficult to thicken, whilst a thick nib will make it difficult to achieve a fine, delicate line.

Subject

The fluid body shapes and sharp angular characteristics of the langoustine claws make them an ideal subject for line drawing using a dip pen and ink. To do the subject justice and successfully convey its three-dimensional qualities you will need to produce lines possessed of thick, thin, fluid, angular, dense and pale characteristics, using a single steel nib.

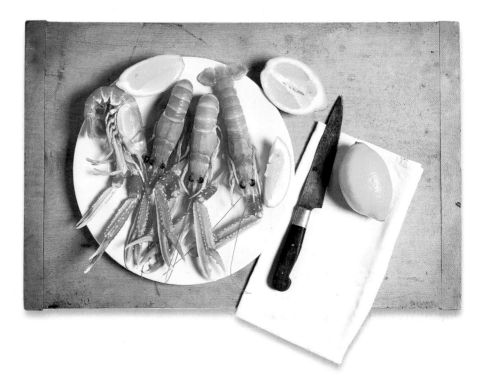

Materials

Soft graphite stick

*Sheet of cartridge (drawing)
paper 495 x 685mm (19½ x 27in)*

Dip pen with medium nib

Black Indian ink

1 Begin by sketching in the main elements, position and simplified shape of each langoustine using a soft graphite stick (or pencil if you prefer). This sketch should be simple and you do not need to religiously follow what you see here; use it as a guide. The pencil lines will disappear beneath the ink work and any that still show when the drawing is complete are easily erased. Begin the drawing on the left-hand side if you are right-handed and on the right-hand side if you draw with your left hand. This prevents the drawing hand brushing over and smudging the wet ink as you work.

2 The ink can be made less black and slightly more fluid by dipping your pen into a jar of water then quickly into your bottle of ink. Try to use less pressure when making long, fluid, light lines and heavier pressure to make darker, thicker lines. If the nib is full but the ink refuses to flow, turning the nib on its side can sometimes restart the flow of ink.

3 As you work, relate the position of each langoustine to the one next to it. Block in the eyes with solid pen work but leave a little white showing to indicate the highlight shine. Take care when drawing the segmented lemon to carefully describe its wedge-like shape; this is helped by indicating a few lines on the darker side only. If you are unsure of the type of line to make, practise on a sheet of scrap paper before committing yourself.

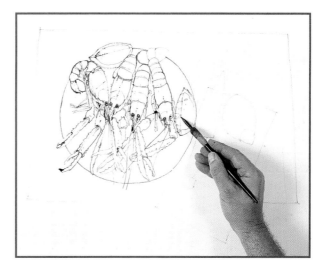

4 Draw in the half lemon to the side of the plate and the knife. Notice how the sharp side of the blade is indicated using a thinner, less dense line than the blunt back of the blade. As you work be aware of not only the outline but any internal linear pattern or texture which, when indicated on the drawing, give clues to the internal contours of the object.

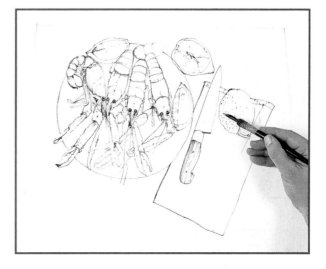

5 Using firm pressure, draw in the edges of the wooden chopping board. Then, using the nib on edge with little pressure and dilute ink, draw a series of roughly parallel lines across the board area to indicate the grain of the wood. Draw in the texture and pattern on the langoustine claws using a series of dots, rough circles and dashes.

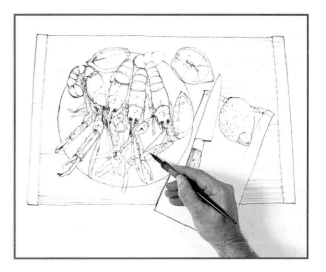

6 Make the final touches to the langoustine shells using a series of lines to help indicate and accentuate their curvature. Complete the drawing by working in the cast shadows using a series of cross-hatched lines. Any graphite underdrawing can now be erased, but make sure that the ink work has dried thoroughly otherwise it will smudge.

Artist's tip
Do not panic if the sharp nib catches or sticks into the paper causing the ink to spatter or blot or if a line appears out of place. Instead, think of these things as part of the drawing process and you will be surprised how they integrate into the drawing rather than stand out.

TRY A DIFFERENT ...

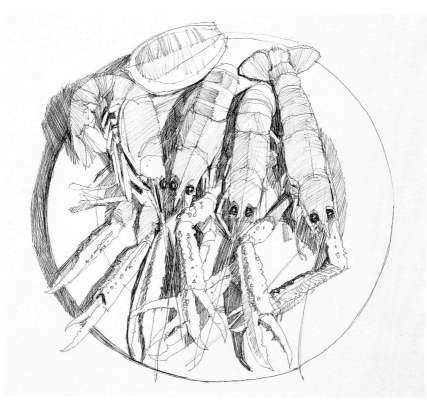

... MEDIUM

A simplified drawing of the same subject was made using a conventional ballpoint pen. The steady flow of ink enables the drawing to be made at speed. Slight pressure delivers a lighter line whilst heavier pressure allows the line to become darker.

... ARRANGEMENT

Arranging the langoustine in a row on their sides gives a similar but slightly more ordered arrangement. Using other seafood such as lobster or crab would present a similar challenge.

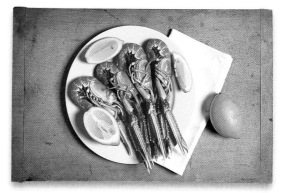

Demonstration 7

Dried Flowers *Pen and wash*

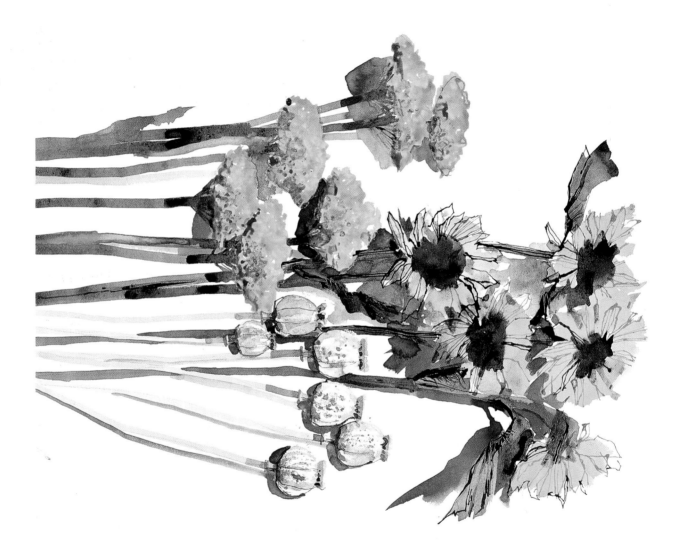

By introducing coloured ink into your drawings a whole new range of exciting possibilities are created. The inks can be used at full strength, thinned with clean water and mixed together in much the same way as traditional watercolour paint. In practice, ink behaves very much like watercolour and most traditional watercolour techniques and tools can be used. The one difference you will find is that if waterproof rather than watersoluble inks are used you will not be able to re-wet and rework areas once the

inks are dry. Several different implements are used to apply the ink including a steel pen, a bamboo pen and various brushes. However, I also used a piece of card and a sponge to paint the fluffy, dried heads of *Achillea*, and a clear wax candle is used to draw the dried poppy heads and act as a resist when overpainted with thinned ink. The secret to making drawings like this is to forget about specific rules and convention and concentrate on invention. Have a little fun with your materials and experiment with them in order to find out exactly what they are capable of. Try not to be too concerned with obtaining too faithful a representation, but aim for a drawing that creates an impression of the flowers by using marks which attempt to describe their various individual characteristics.

Use a medium-weight NOT (cold pressed) surface watercolour paper for your drawing as this should take the ink washes quite easily without cockling (wrinkling) and is smooth enough to allow the steel nib to move easily over its surface without snagging on the paper fibres.

Subject

Due to the drying process these flowers are crisp and angular. These qualities, combined with their interesting surface texture, pattern and fabulous earthy colours, make them a perfect subject for an expressive ink drawing.

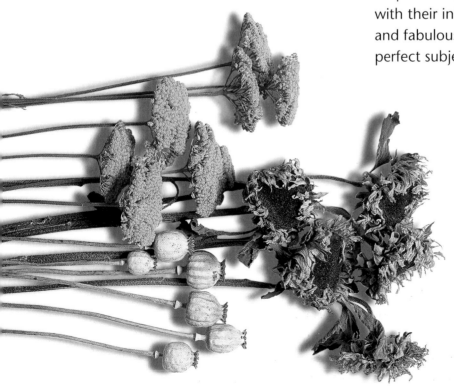

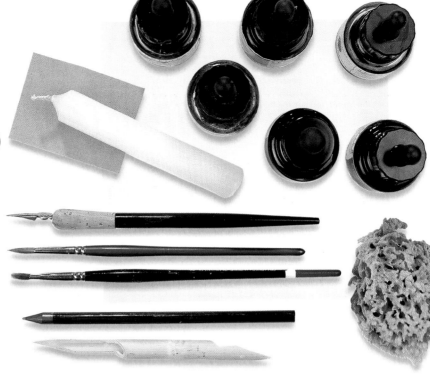

Materials

Sheet of NOT (cold pressed) watercolour paper 500 x 700mm (20 x 28in)

Soft graphite stick

Yellow, sepia, orange, cobalt blue, olive green and ivory black waterproof inks

Small piece of thick card

Natural sponge

1cm (¼in) flat sable brush

Clear candle

No. 6 round sable brush

Dip pen with medium steel nib

Bamboo pen

1 Draw a light graphite pencil sketch to use as a guide. The *Achillea* heads are painted using the yellow ink and a small, chisel-shaped piece of card. This leaves marks which are slightly different to those made with a brush and allows the thick, drying ink to be manipulated into dense blobs. Allow to dry.

2 Mix the orange ink with a little sepia. Using a small piece of natural sponge, apply this colour, using a dabbing motion, around the base of each flower head.

3 Dull the olive green ink by adding a little sepia and thin it with water. Use this colour with the flat brush to paint in the *Achillea* stems. Make the thin stems just below the flower heads by pulling out colour from the main stem with the edge and corner of the brush. As the stems dry, introduce a stronger mix of olive green and sepia into the still wet ink just below each of the flower heads.

4 The ribbed pattern around the seedhead of each poppy is drawn using the candle. Work within the shape indicated by your sketch. You will see little actual marking on the support, but resist the temptation to redraw as you may overdo the wax, which will spoil the effect.

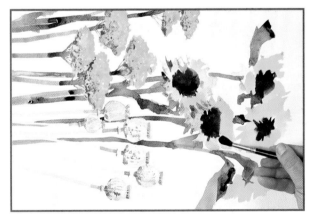

5 Mix a light ochre colour using a little sepia, yellow and black ink, together with plenty of water. Use to paint the seed-heads and stems of the poppies. The wax resists the thin ink and causes the pattern on each seed-head to be revealed.

6 Mix a similar green to that used in step 3. Use it to paint in the stems of the sunflowers. Paint them so that they lie behind the *Achillea* and poppies. Mix blue and sepia for the sunflower centres. Once this is dry, dilute a mix of yellow and ochre with water and wash in the pale yellow petals using the round sable brush.

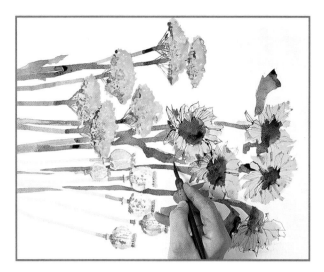

7 Allow the sunflower petals to dry. Use the dip pen together with sepia and orange ink to draw in the shape of the petals surrounding the dark sunflower centres. Use the pen in short, sharp strokes, constantly changing direction and alternating the angle of the nib. Try to manipulate the pen in any way that you can to copy the crinkled, dry appearance and pattern of the petals.

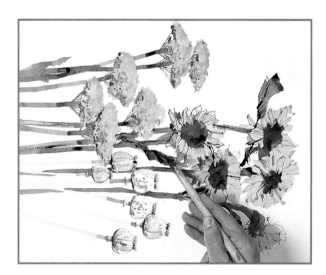

8 Use undiluted black and sepia ink with the dip pen on several of the poppy heads. Using the same colours, but with the bamboo pen, draw in the coarser, linear patterns on the sunflower stems. The bamboo pen will feel stiffer than the steel nib dip pen and will make a coarser, less fluid line.

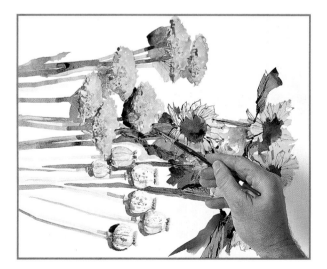

9 Mix cobalt blue and black inks with water to get a dull, dark blue colour. Use this colour with the flat brush to paint in the shadows behind the flowers. Notice that with this simple addition, the flowers immediately appear to be anchored, resting on a white surface, rather than floating in a white space.

TRY A DIFFERENT ...

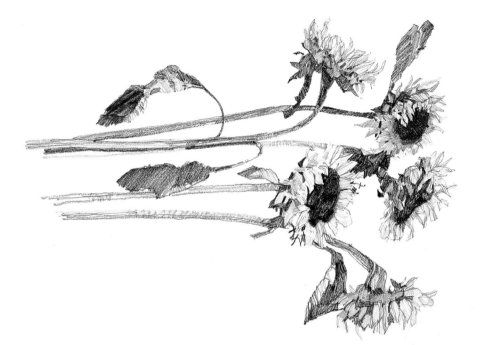

... MEDIUM

This alternative drawing isolates the five sunflowers and attempts a more analytical drawing using pastel pencils and graphite sticks. The pastel pencils add colour but it is the linear, graphite work that sharpens up the piece and makes sense of the jumble of dried petals around each seed-head.

... ARRANGEMENT

A more traditional way of representing flowers is by putting them in a vase or pot. This old, Moroccan, earthenware jar is the perfect container for these dried flowers. The deep shadow cast onto the wall adds extra interest.

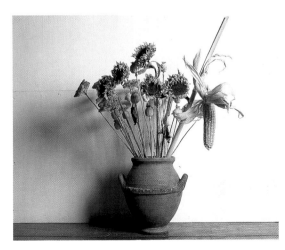

Demonstration **8**

Fresh Flowers *Pastel pencils*

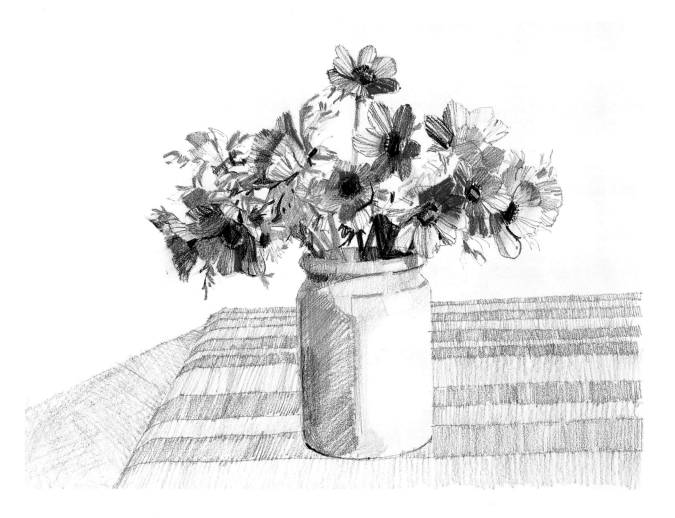

The limited range of colours used are more than enough to make a satisfactory drawing. Keeping the pastel pencil work open and allowing some of the support to show through lends a sense of lightness to the piece, which is perfectly in keeping with the subject matter.

Care needs to be taken when using colour in drawings. At all costs you should aim to avoid the "filled in" look where the drawing is made using line and any colour added after filling in the spaces. Colour should be used as an integral part of the drawing process from the outset. Pastel pencils have

similar characteristics to traditional coloured pencils in that colours can be built up by laying one over another. However, pastel pencils make bolder, coarser marks and leave loose pigment on the support surface; all of which make them more difficult to work with on a smaller scale. Far from being a drawback, these characteristics can actually help as it forces the artist to work at a larger scale whilst keeping the pencil marks open and loose. Pastel pencils also have an added advantage in that the colour can be smudged and blended prior to being fixed. This allows tonal colour work to be combined with incisive linear work. Mistakes can also be rectified, which is always reassuring for the beginner. Pastel pencils erase quite easily using vinyl or putty erasers. Alternatively, line work can be lightened by rubbing with a stiff bristle brush.

Subject

Flowers are the still-life artist's perennial favourite and always make a splendid subject regardless of the medium being used. The wide range of shapes and vibrant colour combinations present a constant challenge. Short, stocky, brilliantly coloured anemones are used here, dropped into a simple stoneware pot with no attempt at arrangement. The support is covered with a piece of cloth and the set-up is lit from the right.

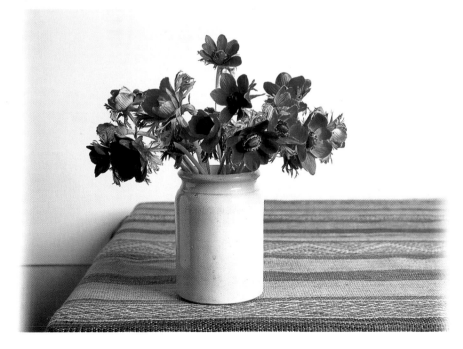

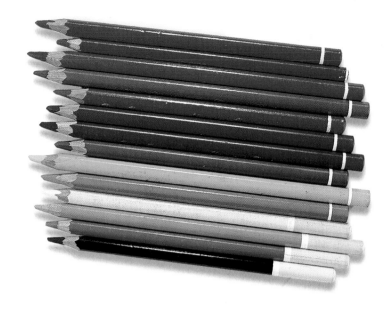

Materials

*Sheet of cartridge (drawing)
paper 594 x 420mm
(16½ x 23½in)*

*Pastel pencils: scarlet red,
dark red, pink carmine,
ultramarine, violet, manganese
violet, juniper green, olive
green, chromium green,
may green, ivory, warm grey,
brown ochre, black*

Fixative

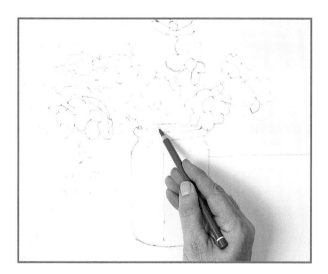

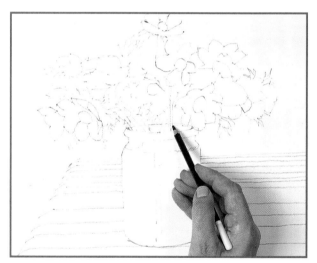

1 Begin by using the warm grey pencil to establish the shape and position of the pot; this is placed more or less centrally on the support. Using the same pencil, draw the position of the cloth. This places the pot of flowers firmly on something rather than letting it float in space. Establish the position and shape of the flowers next. Draw each one in the colour which corresponds to the flowers' actual colour. Work across the bunch positioning each flower head relative to the flower next to it and the top or lip of the pot.

2 Continue positioning all of the elements by drawing in the pattern of the cloth in grey and the foliage and the stems using the olive green pencil. Use black for those stems deep in shadow. In order to prevent your hand smudging out the work you have done so far you may find it helps to lightly spray the image with fixative.

3 Draw the flower heads colour by colour, starting with the purple flowers on the left. Use black to block in the flower centres and also for those petals in shadow. Keep the pencil work fairly open as there is no need to try to obliterate every last trace of the white support. Use a combination of violet and manganese violet to add colour to the petals. Then move across to treat the blue flowers in the central area in the same way; using black, ultramarine and the two violets.

4 Once the colour on the violet and blue flowers has been established, turn your attention to the red flowers. These are treated in the same way using a combination of the black and red pastel pencils. On all of the flower heads, an occasional smudge with the finger blends or subdues a colour. Rework this area with a few darker, more incisive linear marks to suggest the linear pattern on the petals.

5 Use black to draw in those stems and parts of the leaves that are in deep shadow. Where the leaves catch the light use may green. Use chromium green and olive green in middle tone areas. Work carefully around each of the flower heads so as not to obscure their shapes.

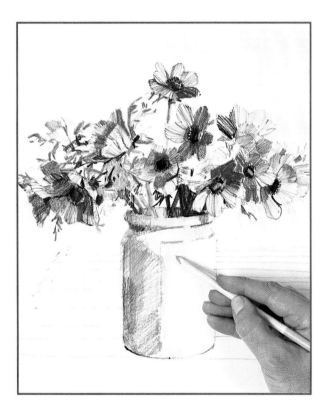

6 Once the flowers have been completed, turn your attention to the pot. Use black, warm grey and a little brown ochre on the shaded side of the pot. Add a little ultramarine on the left-hand side of the lip where there is some reflected colour from the purple flower heads above. Scribble ivory over the right-hand side which faces the light source.

7 All that remains is to use a combination of warm grey and black to scribble in the shadow cast across the white wall. Use linear strokes to represent the weave of the cloth; draw the black pattern followed by the red. A final spray of fixative will ensure the work does not become smudged.

Artist's tip
When applying one colour over another it is important that a certain amount of the support is allowed to show through the first colour applied so that the second colour has some white paper to adhere to.

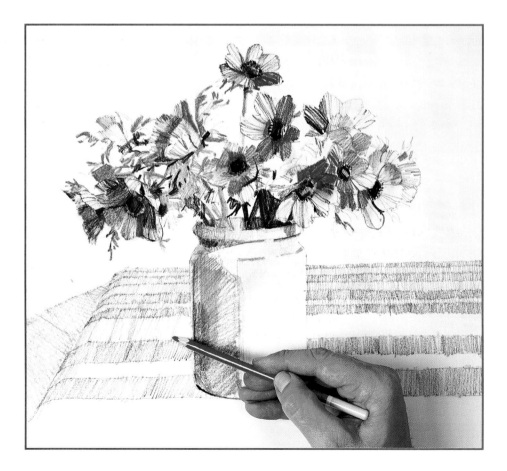

TRY A DIFFERENT ...

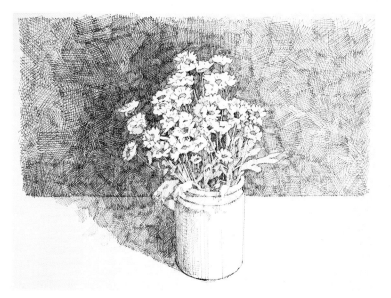

... MEDIUM

A single nylon-tipped black fine liner was used to make this drawing of buttercups, arranged in the same pot. A very light rough pencil sketch enabled the drawing to be made and, if necessary, corrected before the pen was used. Simple cross-hatching combined with some line work then "carved" the image out of the white paper. Do not be tempted to work on too large a scale when making drawings like this as it can take some time to build up the intricate web of lines.

... ARRANGEMENT

The variations on the theme are endless. As you progress in confidence try more and more complex arrangements. Try placing flowers in a glass vase so that the stems are visible or make a drawing of the flowers as they are about to be removed from their coloured paper wrapping.

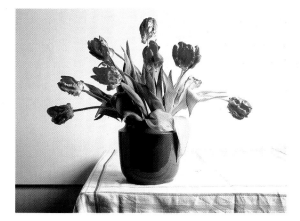

Demonstration 9

Teapot and Cups
Pen and watercolour wash

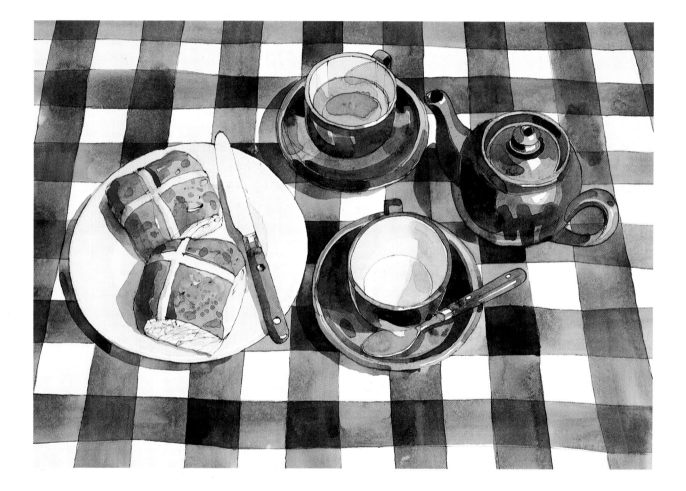

Colour can be introduced into your drawings by using watercolour washes. Watercolour can be used with any drawing medium but if using extensive washes you will need to work on stretched watercolour paper or on a heavyweight paper which does not need to be stretched. Thin or lightweight paper needs to be stretched because the paper fibres absorb water and swell. As the paper dries out it tends to buckle or cockle and the resulting uneven surface is difficult to work on. Stretching the paper ensures that it dries

flat after every wash. All papers can be stretched, although some are easier to stretch than others. Very thin papers can be awkward, with medium-weight papers being the easiest.

The other consideration when making a drawing is the quality and texture of the paper's surface. You need to match the drawing material with the support surface.

As a general rule, ink and dip pen are easier to use on a smooth surface paper. On a rough surface the sharp nib tends to dig into the paper fibre. Pencil takes on most surfaces whilst dusty materials like charcoal or pastel need a degree of tooth or texture so that the pigment dust has something to cling to. On smooth surfaces it tends to fall off, which makes it impossible to make very dark tones.

Subject

A couple of cups and saucers, a teapot and buns are grouped on a chequered cloth to create a very casual arrangement. The gridded cloth pattern holds the elements together, whilst the dark reflective surfaces on the cups, saucers and teapot give added interest.

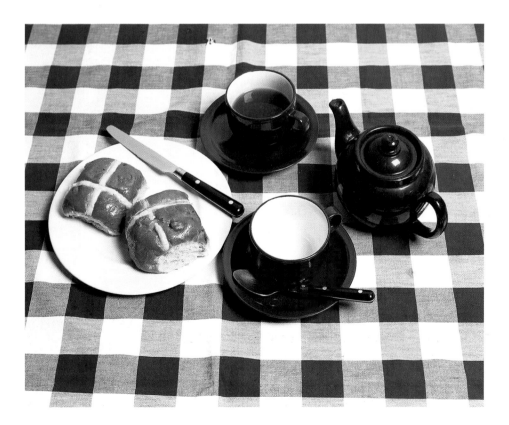

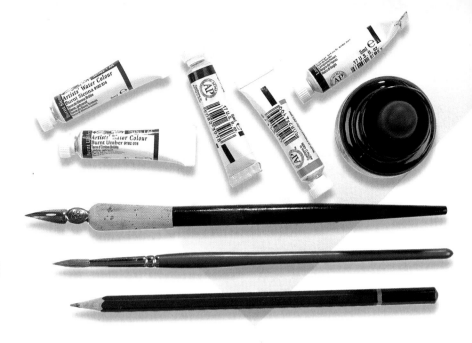

Materials

Soft pencil

*Sheet of NOT (cold
pressed) surface
watercolour paper
380 x 560mm (15 x 22in)*

*Dip pen with medium
steel nib*

Black Indian ink

No. 6 round sable brush

*Yellow ochre, burnt sienna,
burnt umber, Paynes grey,
ivory black watercolour paints*

1 Sketch out the composition using a soft
pencil. Any visible pencil line that is not
required in the finished drawing can be
erased once the ink drawing has been
completed, but before the watercolour
washes are added. Using the dip pen and
ink, begin by drawing in the two buns, plate
and knife. Search out and indicate any
textures on the two buns.

2 Move on to the cups and saucers. Work
using a light pressure and fluid strokes.
The ink should flow easily on the smooth
paper. Draw in not only the linear outline of
the cups but also indicate the main
reflections. Be aware of trying to draw the
ellipses as well as you can but do not panic if
they are not perfect; the initial pencil
drawing should assist here.

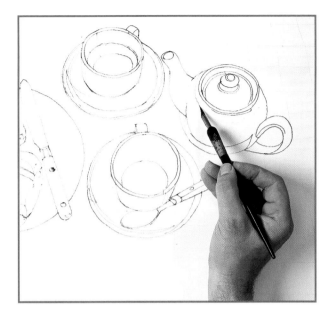

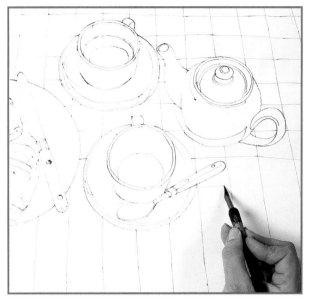

3 Draw the teapot in the same way. Pay particular attention to the shape of the handle and the spout, which lie along the same axis, falling directly opposite one another on either side of the pot. As before, indicate some of the internal reflections. Take care when drawing the pot lid to ensure that it fits inside the top of the pot.

4 The pen work is completed by drawing in the grid of lines which make up the chequered pattern on the tablecloth. Pay particular attention to the angle of the lines, which run front to back, as it is these that give the drawing its sense of depth. Draw the vertical lines first, but make sure they are dry before drawing the horizontal lines or you may smudge them.

5 Paint a very light wash of yellow ochre mixed with a little ivory black over the plate, the buns and inside the two cups. When dry, paint the dark, outer layer of the two buns using a wash of burnt sienna mixed with yellow ochre. Allow the washes to dry before continuing. The drying process can be speeded up by using a hair-drier, but be careful not to blow the wet paint into areas where it is not wanted.

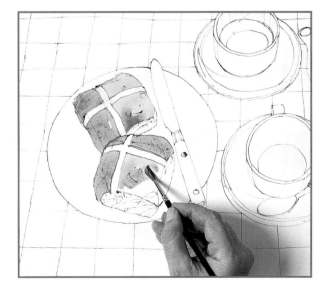

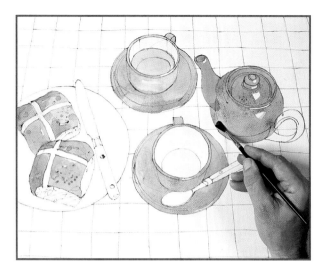

6 Use a wash of burnt sienna and burnt umber for the dark areas on the buns. Add more umber and plenty of water, then use this mix to give colour and tone to the cups and the teapot. Work around the lightest reflections, leaving these to show through as white paper. Thin this mixture further and paint in the tea which half-fills the top cup.

7 Make a dark grey using Paynes grey with a little ivory black. Use this to paint in the handles of the knife and spoon; work around any white highlights. Use a yellow ochre and burnt umber mix for the tea and a thin, grey mixture to paint in the shadows on the white insides of both cups. Allow to dry. Mix burnt sienna, burnt umber and black to make a dark reddish-brown and use it to paint in the dark reflections on the crockery.

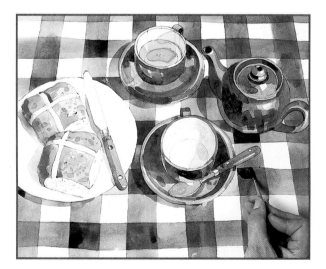

8 To complete the drawing use the dark grey to paint in the shadow on the knife handle. Add a little more grey and water and paint in the vertical pattern on the cloth. Once this is dry, paint in the horizontal pattern and allow this to dry. Use the same grey to paint in the shadows cast on the tablecloth by each piece of crockery. Allow to dry. Finish off the drawing by using a darker grey on a few of the cloth squares.

TRY A DIFFERENT ...

... MEDIUM

I used terracotta, black and white artists' pencils on cream paper to draw a bottle and two glasses. The reflective surfaces are represented in much the same way as in the demonstration, but a compromise needed to be found between the solidity of the objects and the transparency of the material they are made from.

... ARRANGEMENT

An unusual drawing could be made by looking down on the objects from directly overhead. The tray is used as a device to frame the objects, whilst placing the tray at an angle to the pattern on the cloth increases the interest and adds tension to the piece.

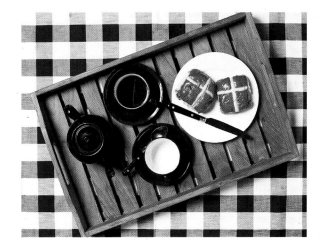

Demonstration **10**

Vegetables
Graphite pencil and stick

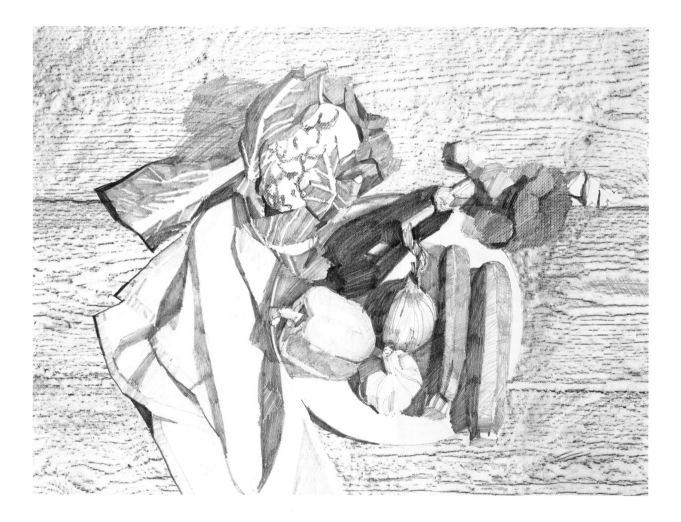

Frottage is a technique that you may not use very often, but it can be extremely handy to have in your repertoire (see page 14). Sometimes drawings don't seem to be working as we would like them to. No matter what marks are made they seem to be wrong. A little frottage could be the answer. Using frottage will give a very different look to a drawing and create some beautiful textures. One of the nicest things

about frottage is you never quite know what the effect will be like or even if it will work. For this reason it is best to practise on a piece of scrap paper identical to the piece you are making the drawing on before committing yourself. The secret to frottage is to be inventive, as the most unlikely things can be used to create a texture.

Remember that you can only use frottage when working on relatively thin papers as thicker papers will not allow the texture to show through. One solution is to make your textural frottage on one sheet of paper and collage this on to your drawing. Like most techniques, frottage can be overdone and perhaps is at its most successful when it is not immediately apparent. Incorporating a technique like frottage into a drawing made using other techniques can be difficult and it requires a degree of sensitivity and thought.

Subject

A few different vegetables provide the subject for this still life. All have varying surface textures that need to be treated in different ways. The broccoli, cauliflower and rough wooden table give the perfect excuse to practise the frottage technique.

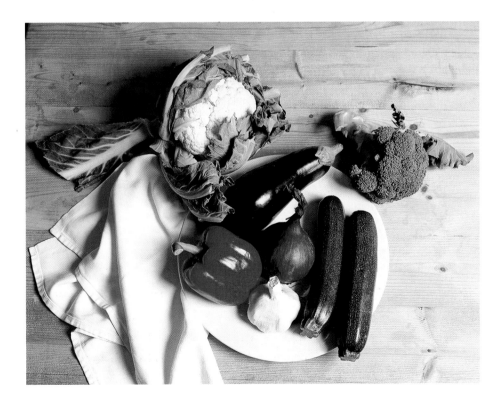

Materials

2B pencil

Sheet of white cartridge (drawing) paper 594 x 420mm (16½ x 23½in)

Plastic eraser

4B graphite stick

Plank of rough wood

Canvas painting panel

Fixative

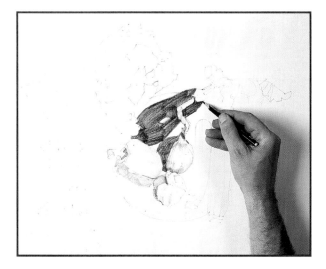

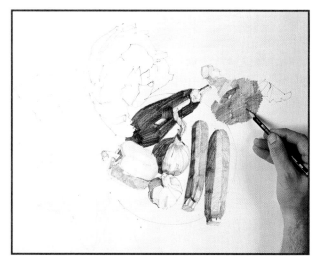

1 Using the 2B pencil, sketch in the vegetables and the napkin. Once you are satisfied with their positions you can begin to add tone using the graphite stick. Work on the red pepper then the bulb of garlic. The dried outer garlic skin is covered in linear marks; draw some of these lines in as they show up the contours of the hidden cloves. Similar lines describe the round shape of the onion; notice how the dried skin is twisted at the neck. The deep purple aubergine is the darkest vegetable and you will need to press hard to make the graphite tone sufficiently dark.

2 Draw the courgettes next. The flat facets of these two vegetables have different tones according to where they are in relation to the light source. To draw the stem and florets of the broccoli, place the sheet of paper over the canvas panel and scribble over the area of the broccoli head with the pencil. The dark graphite picks up on the texture of the board, leaving an area of tone which reads as tiny broccoli florets.

3 The cauliflower head is drawn in the same way. However, the colour of the head is lighter so only apply tone to those areas in shadow. Use the 2B pencil to draw in the cauliflower leaves, working around the lighter tracery of the veins in each leaf. These are left to show as white paper. Extra veins can be made by drawing into the tone using the eraser.

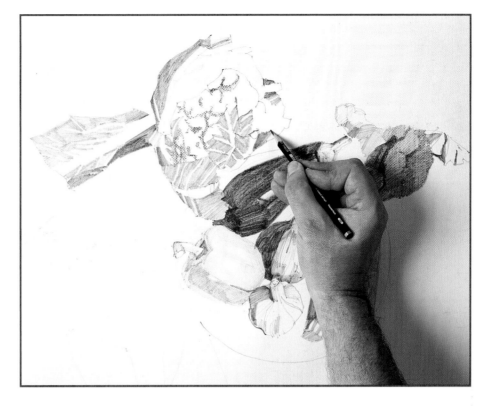

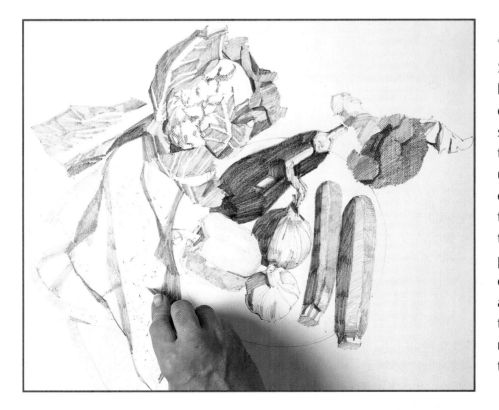

4 Draw the white table napkin next. Scribble an overall light tone and then draw in the folds and shadows. Clean up the lightest areas using a hard plastic eraser. Cut back through the graphite to reveal the white paper. Use a combination of tone and line to suggest the puckering of material seen along the napkin seams.

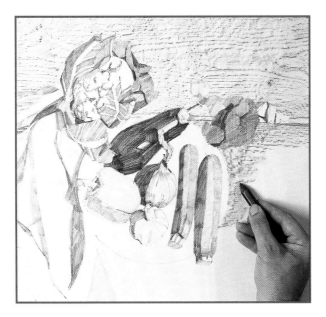

5 Once you have drawn the vegetables, the wooden table-top can be established. Place the plank of wood underneath the paper so that it runs horizontally across the top third of the drawing. Hold the drawing in place with one hand, whilst using the 4B graphite stick in the other to scribble over the texture, working around the vegetables. Once you have worked across the width of the drawing move the sheet of paper up so that the plank runs across the middle third of the drawing and repeat the process. Do the same over the bottom third.

Artist's tip

Once you are satisfied with your textural marks, spray the drawing with fixative so that they remain crsip and well defined. Otherwise, they may become smudged whilst doing subsequent work.

6 With the table-top background established, finish the drawing by scribbling in the shadow tones using the 2B pencil. Work the shadows in and around the vegetables – on the white plate and beneath and behind the cauliflower. Work dark shadow beneath the edge of the plate and under the broccoli spear. This has the immediate effect of appearing to lift the objects clear of the table-top.

TRY A DIFFERENT ...

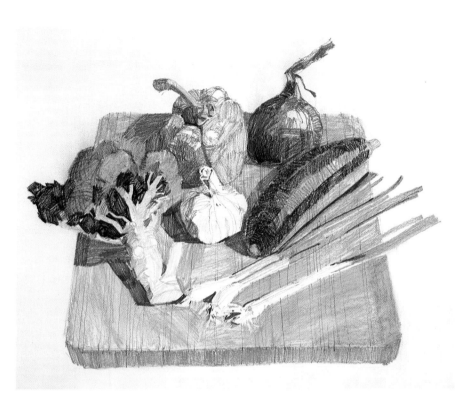

... MEDIUM

This drawing of vegetables on a wooden chopping board was made using pastel pencils. The wood grain and the shadows were drawn in using a soft graphite pencil.

... ARRANGEMENT

This is a slightly more involved arrangement with the vegetables placed on a wooden board, which sits on a chequered cloth. The pepper is cut in half to reveal the seeds inside. Again, the view is from above which shows up the shape of each vegetable more than if they were seen from a lower angle.

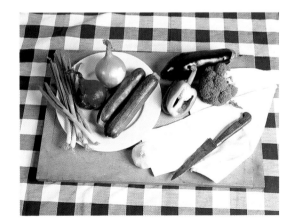

Suppliers

UK

Cass Arts
13 Charing Cross Road
London WC2H 0EP
Tel: (020) 7930 9940
&
220 Kensington High Street
London W8 7RG
Tel: (020) 7937 6506
Website: www.cass-arts.co.uk
Art supplies and materials

L Cornelissen & Son Ltd
105 Great Russell Street
London WC1B 3RY
Tel: (020) 7636 1045
&
1a Hercules Street
London N7 6AT
Tel: (020) 7281 8870
General art supplies

Cowling and Wilcox Ltd
26-28 Broadwick Street
London W1V 1FG
Tel: (020) 7734 9558
Website: www.cowlingandwilcox.com
General art supplies

Daler-Rowney Art Store
12 Percy Street
Tottenham Court Road
London W1A 2BP
Tel: (020) 7636 8241
Painting and drawing materials

Daler-Rowney Ltd
PO Box 10
Southern Industrial Estate
Bracknell
Berkshire RG12 8ST
Tel: (01344) 424621
Website: www.daler-rowney.com
Painting and drawing materials
Phone for nearest retailer

T N Lawrence & Son Ltd
208 Portland Road
Hove BN3 5QT
Shop tel: (01273) 260280
Order line: (01273) 260260
Website: www.lawrence.co.uk
Wide range of art materials
Mail order brochure available

John Mathieson & Co
48 Frederick Street
Edinburgh EH2 1EX
Tel: (0131) 225 6798
General art supplies and gallery

Russell & Chapple Ltd
68 Drury Lane
London WC2B 5SP
Tel: (020) 7836 7521
Art supplies

The Two Rivers Paper Company
Pitt Mill
Roadwater
Watchet
Somerset TA23 0QS
Tel: (01984) 641028
Hand-crafted papers and board

Winsor & Newton Ltd
Whitefriars Avenue
Wealdstone
Harrow
Middlesex HA3 5RH
Tel: (020) 8424 3200
Website: www.winsornewton.com
Painting and drawing materials
Phone for nearest retailer

SOUTH AFRICA

CAPE TOWN
Artes
3 Aylesbury Street
Bellville 7530
Tel: (021) 957 4525
Fax: (021) 957 4507

GEORGE
Art, Crafts and Hobbies
72 Hibernia Street
George 6529
Tel/fax: (044) 874 1337

PORT ELIZABETH
Bowker Arts and Crafts
52 4th Avenue
Newton Park
Port Elizabeth 6001
Tel: (041) 365 2487
Fax: (041) 365 5306

JOHANNESBURG
Art Shop
140a Victoria Avenue
Benoni West 1503
Tel/fax: (011) 421 1030

East Rand Mall Stationery and Art
Shop 140
East Rand Mall 1459
Tel: (011) 823 1688
Fax: (011) 823 3283

PIETERMARITZBURG
Art, Stock and Barrel
Shop 44, Parklane Centre
12 Commercial Road
Pietermaritzburg 3201
Tel: (033) 342 1026
Fax: (033) 342 1025

DURBAN
Pen and Art
Shop 148, The Pavillion
Westville 3630
Tel: (031) 265 0250
Fax: (031) 265 0251

BLOEMFONTEIN
L&P Stationary and Art
141 Zastron Street
Westdene
Bloemfontein 9301
Tel: (051) 430 1085
Fax: (051) 4304102

PRETORIA
Centurion Kuns
Shop 45, Eldoraigne Shopping Mall
Saxby Road
Eldoraigne 0157
Tel/fax: (012) 654 0449

AUSTRALIA

NSW

Eckersley's Art, Crafts and Imagination
93 York St
SYDNEY NSW 2000
Tel: (02) 9299 4151
Fax: (02) 9290 1169

Eckersley's Art, Crafts and Imagination
88 Walker St
NORTH SYDNEY NSW 2060
Tel: (02) 9957 5678
Fax: (02) 9957 5685

Eckersley's Art, Crafts and Imagination
21 Atchinson St
ST LEONARDS NSW 2065
Tel: (02) 9439 4944
Fax: (02) 9906 1632

Eckersley's Art, Crafts and Imagination
2-8 Phillip St
PARRAMATTA NSW 2150
Tel: (02) 9893 9191 or
1800 227 116 (toll free number)
Fax: (02) 9893 9550

Eckersley's Art, Crafts and Imagination
51 Parry St
NEWCASTLE NSW 2300
Tel: (02) 4929 3423 or
1800 045 631 (toll Free number)
Fax: (02) 4929 6901

VIC

Eckersley's Art, Crafts and Imagination
97 Franklin St
MELBOURNE VIC 3000
Tel: (03) 9663 6799
Fax: (03) 9663 6721

Eckersley's Art, Crafts and Imagination
116-126 Commercial Rd
PRAHRAN VIC 3181
Tel: (03) 9510 1418 or
1800 808 033 (toll free number)
Fax: (03) 9510 5127

SA

Eckersley's Art, Crafts and Imagination
21-27 Frome St
ADELAIDE SA 5000
Tel: (08) 8223 4155 or
1800 809 266 (toll free number)
Fax: (08) 8232 1879

QLD

Eckersley's Art, Crafts and Imagination
91-93 Edward St
BRISBANE QLD 4000
Tel: (07) 3221 4866 or
1800 807 569 (toll free number)
Fax: (07) 3221 8907

NT

Jackson's Drawing Supplies Pty Ltd
7 Parap Place
PARAP NT 0820
Tel: (08) 8981 2779
Fax: (08) 8981 2017

WA

Jackson's Drawing Supplies Pty Ltd
24 Queen St
BUSSELTON WA 6280
Tel/Fax: (08) 9754 2188

Jackson's Drawing Supplies Pty Ltd
Westgate Mall, Point St
FREEMANTLE WA 6160
Tel: (08) 9335 5062
Fax: (08) 9433 3512

Jackson's Drawing Supplies Pty Ltd
108 Beaufort St
NORTHBRIDGE WA 6003
Tel: (08) 9328 8880
Fax: (08) 9328 6238

Jackson's Drawing Supplies Pty Ltd
Shop 14, Shafto Lane
876-878 Hay St
PERTH WA 6000
Tel: (08) 9321 8707

Jackson's Drawing Supplies Pty Ltd
103 Rokeby Rd
SUBIACO WA 6008
Tel: (08) 9381 2700
Fax: (08) 9381 2525

NEW ZEALAND

AUCKLAND

Draw-Art Supplies Ltd
5 Mahunga Drive
Mangere
Tel: (09) 636 4986
Fax: (09) 634 5162

The French Art Shop
33 Ponsonby Road
Ponsonby
Tel: (09) 376 0610
Fax: (09) 376 0602

Studio Art Supplies
81 Parnell Rise
Parnell
Tel: (09) 377 0302
Fax: (09) 377 7657

Gordon Harris Art Supplies
4 Gillies Ave
Newmarket
Tel: (09) 520 4466
Fax: (09) 520 0880
&
31 Symonds St
Auckland Central
Tel: (09) 377 9992

Design Art Supplies
Atrium on Elliot
Auckland Central
Tel: (09) 303 3177

WELLINGTON

Websters
44 Manners Street
Tel: (04) 384 2134
Fax: (04) 384 2968

Affordable Art
10 McLean Street
Paraparaumu\
Tel/Fax: (04) 902 9900

Littlejohns
170 Victoria Street
Tel: (04) 385 2099
Fax: (04) 385 2090

CHRISTCHURCH

Fine Art Papers
200 Madras Street
Tel: (03) 379 4410
Fax: (03) 379 4443

Brush & Palette
50 Lichfield Street
Christchurch
Tel/Fax: (03) 366 3088

DUNEDIN

Art Zone
57 Hanover St
Tel/Fax: (03) 477 0211

Index